PRESTON
Remembered

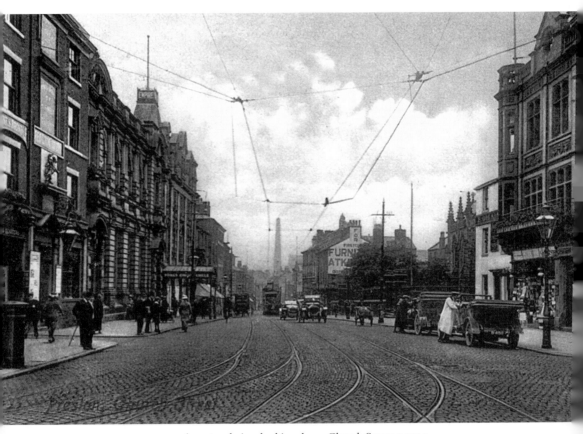

A postcard view looking down Church Street, *c.* 1925.

PRESTON
Remembered

KEITH JOHNSON

First published 2011

The History Press
The Mill, Brimscombe Port
Stroud, Gloucestershire, GL5 2QG
www.thehistorypress.co.uk

ISBN 978 0 7524 6035 2

Typesetting and origination by The History Press
Printed in Great Britain

Manufacturing managed by Jellyfish Print Solutions Ltd

CONTENTS

About the Author 6

Acknowledgements 6

Foreword 7

Introduction 8

1.	The People who Made Preston Proud	9
2.	The First Citizens of our City	15
3.	Freemen Fit for a City	18
4.	Making a Lasting Impression	22
5.	In the Footsteps of the Friars	26
6.	In Search of Preston's High Street	31
7.	Tithebarn – Times They are A-Changing	35
8.	Those Taverns in the Town	38
9.	Read All About It	44
10.	On the Buses	46
11.	What a Picture: The Golden Age of the Silver Screen	51
12.	Our Green and Pleasant Lands	55
13.	First Class: the Post	59
14.	Remember, Remember the Fifth of November	62
15.	Banking on Preston	66
16.	Preston Bobbies on Parade	70
17.	Full Steam Ahead	74
18.	Thank God for Churches	80
19.	Hallowe'en Hauntings	84
20.	Dawn of the Dead	88
21.	Grave Matters Once More	91
22.	Fulwood – Pride of Preston?	94
23.	Bypassing Broughton	97
24.	Who Were the Invincibles?	100
25.	The Golden Days of Doctor Syntax	107
26.	Goodbye Old Stand	110
27.	Imagine an Easter when …	113
28.	All the Fun of the Whitsuntide Fair	116
29.	Waking Up to Wakes Weeks	119
30.	Those Twentieth-Century Christmas Times	121

ABOUT THE AUTHOR

Keith Anthony Johnson is Preston born and bred. A former pupil of St Augustine's Boys' School, he completed his studies at the Harris College – now Preston's university. A keen local historian, Keith has worked in the city all his life, being employed as an engineering designer in the printing-press industry for almost four decades. In recent years, as the *Lancashire Evening Post* historian, he has contributed regular articles to the newspaper. His previous works include the local bestselling *Chilling True Tales of Old Preston* series of books, the popular *People of Old Preston*, the regional bestseller *Chilling True Tales of Old Lancashire* and *Chilling True Tales of Old London*.

ACKNOWLEDGEMENTS

I am indebted to the staff of the Harris Reference Library for their assistance, given so willingly, in my gathering of information and suitable images/illustrations.

I express my appreciation to the Preston historians and newspaper reporters whose accounts of past events are a delight to research – historical information all painstakingly recorded in the *Preston Chronicle*, *Preston Guardian*, *Preston Pilot*, *Preston Herald* and the *Lancashire Evening Post*, leaving a legacy of knowledge.

I also wish to thank the Preston Digital Archive for permission to use images/photographs from their collection. My thanks go also to Glen Crook and James Fielding, for photographs and line sketches as appropriate.

FOREWORD

Any journey through the history of Great Britain could be told through the life and times of Preston. From its entry in the Domesday Book to the Queen bestowing City status in 2002 to mark her 50th year on the throne, Preston's story has been a rich and varied one. Its soldiers have fought in foreign fields, its workers have provided the heartbeat for the industrial revolution which changed our land forever, and its sportsmen have risen to become heroes to millions.

For the past 125 years, the *Lancashire Evening Post* has been proud to cover the city we call home. While bringing the latest news to our readers, we have always found time to look back and revisit the everyday stories of Preston life, both big and small. And for that we so often turn to Keith Johnson.

Keith's passion for scouring the archives to shine a light on our past is unrivalled. With a newshound's nose for a story, many has been the day I have switched on my computer to find an e-mail nestling in my inbox from Keith. And it is always with interest that I open it up, knowing I will learn something illuminating about our past. Keith has a great skill for providing an historical perspective on any topical issue which has fired his imagination from that week's headlines.

Just one example from recent times arrived when the *Evening Post* carried a special investigation looking at the number of pub closures in the city in the past few years. Without warning, an e-mail arrived with a well-researched feature charting the history of the city's drinking establishments, listing places familiar to some and long lost to many. This ability to spark old memories and make sense of our past comes from Keith's love of local history. Much of his research is painstakingly plucked from old copies of the newspaper and there is a nice symmetry to being able to bring new generations eyewitness accounts from generations past.

Some of the chapters in this book first saw the light of day in the *Evening Post* in the very way described – with the unprompted arrival of an e-mail. It is great to see them given greater longevity in this fascinating book.

Allow Keith to take you on his own journey through Preston past; there is no finer guide.

Mike Hill, 2011
Deputy Editor, Lancashire Evening Post

INTRODUCTION

Preston, in Lancashire, is a cotton town that became a university city. It was quite a journey and I hope that this book helps to tell the tale of Preston through the centuries. We live in an age of discovery, but can still marvel at the people who shaped the place we live in and the lives they led. Yes, there has been toil and troubles along the way, and grit and determination needed to get many an enterprise on the move. Many great folk have shaped the city's destiny and have served with dignity to keep the pride in Preston. Rich man, poor man, banker and Freeman have all played their part.

It has been a pleasure to research the origins of so many Preston institutions, and to marvel at their advances as the Industrial Age evolved. Many landmarks have disappeared – their time having passed – yet many still remain to keep the link between generations. Monuments and statues too are worth more than a passing glance.

Preston, with its rapid growth in the nineteenth century, had difficult times to endure, but it coped well and the advances in the twentieth century led to it gaining City status at the dawn of the twenty-first century. It is now a sprawling city, some may say, compared with the Victorian town, when most resided within the old borough boundaries, not far from the mill in which they worked or the public house where they spent their leisure time.

Few places are blessed with so many public parks and those, along with the old familiar streets and highways, have historical links of their own.

Delving into the archives is always a nostalgic trip – old cinemas, old footballers, old public houses; they all jog the memory and remind us of days gone by. Then there are the steam engines, the horse-drawn trams, the double-decker buses, the churches and chapels, the graveyards and ghosts, which all have a place in our memories. And, of course, those wonderful customs associated with Easter, Whitsuntide, Wakes Week and Christmas – all of which provide fond recollections.

The great historian Anthony Hewitson, after writing his *History of Preston* in 1883, remarked that it was 'not a perfect place, but amid the toil and hurly-burly of daily life what is?' So reader, if you enjoy this journey, as I did, then I shall be pleased. Begun long ago, the story of the city is never-ending and will continue for many generations to come.

Keith Johnson, 2011

1

THE PEOPLE WHO MADE PRESTON PROUD

Industry, arts and literature have been blessed by the contribution of Preston folk. Once the winter residence of the rich gentry, the town was to take its place at the very heart of the cotton trade. Some residents went on to local or national fame, or prospered despite the poverty of their surroundings – many earning their place in history through feats of human endeavour and achievement, at a time when heroes were not manufactured.

Mention the cotton industry and John Horrocks springs to mind. His life was short, a mere thirty-six years, yet in the thirteen years he spent in Preston he left a lasting impression, having developed a cotton business that would span centuries. Almost yearly he added another cotton factory to his booming business, attracting mill hands from far and wide.

Nor can Sir Richard Arkwright's contribution to industry be ignored. This Preston-born lad developed his spinning frame in Stoneygate, and then headed to Nottingham to develop the factory system of production with his water-powered machinery. Who would have thought that a lad who worked cutting hair and pulling teeth in Bolton would end up with a knighthood?

Local industry still owes a debt to Joseph Foster, a pioneer in the newspaper-printing world. A revolutionary web-feed printing press for the *Preston Guardian* in 1872 was to firmly establish Foster at the front of technology, his inventiveness leading to employment for thousands of local people through the years.

Back in 1948, at a cost of £98, the first Bond Minicars rolled off the production line in Ribbleton Lane. For over a decade these three-wheelers, designed by Lawrence Bond, were a popular mode of

John Horrocks lived a short life but left a lasting legacy.

transport throughout the UK, said to need just one gallon of petrol to travel 100 miles. Bond's groundbreaking design brought cheap transport to many and a hundred vehicles were produced per week, giving employment to many local folk.

Also providing employment was William Henry Woods. In the days before government health warnings, he ran a tobacco factory in Derby Street. With a shop on the corner of Church Street and Avenham Street, the business, begun by his father, thrived, employing hundreds of local workers at the dawn of the twentieth century. He not only built up the business but also played a significant part in the town's affairs, being thrice elected as an alderman.

Another local hero, John Huntington, fought on behalf of workers over a 10 per cent wage reduction imposed by the cotton bosses. The feud was long and bitter, and starvation brought an end to operatives' hopes. The factory gates were locked in Huntington's face and he was forced to flee to America to earn his living. Fate was with him; soon he was instrumental in the discovery of oil and the development of the Standard Oil Co. In his later years, this modest man paid a visit to Preston and his old friends welcomed home a millionaire.

Edith Rigby, a doctor's wife from Winckley Square, also fought hard for her cause, becoming the secretary of the Preston Suffragette Movement and proudly proclaiming 'Votes for Women'. Imprisoned for over-zealous protests, she did not shirk from her beliefs and was a true champion for women's rights.

Another doctor's wife, Avice Pimblett, was a pioneering lady on the local political scene. She was the first woman elected on to Preston Town Council in 1920, the first woman to be Mayor in 1933, and was rewarded for forty years of public service with the Freedom of the Borough.

Other Preston women of note include Frances Lady Shelley and Emma Lyon. The former, of Winckley family descent, became part of high society – mixing with the likes of the Duke of Wellington and Queen Victoria – after marrying a descendant of poet Percy Bysshe Shelley. Emma Lyon, said to have been born of poor parents at Preston, Lancashire in 1764, became the much adored Lady Hamilton, a woman who was to steal the heart of Lord Nelson following their liaison in Naples.

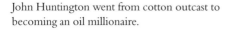

John Huntington went from cotton outcast to becoming an oil millionaire.

Matthew Brown built a thriving brewing business in Preston.

Joseph Livesey, a kindly man who led the Temperance Society.

Preston can boast numerous entrepreneurs and businessmen. Many of the inns and taverns of old Preston carried the name of Matthew Brown, who took over a brewing business from his father and developed a thriving company. It all began in Pole Street, near to where his beloved Anglers Inn once stood, and with the abolition of Beer Duty he soon owned numerous public houses around the town and supplied ale to many others. With similar success, errand lad Edwin Henry Booth built up a chain of stores from his grocery store in the Preston Market Place. The business grew and prospered under his guidance and his belief was 'To Thine Own Self Be True', a philosophy that guided his ways.

Joseph Livesey was also guided by his values, and is regarded by many as one of Preston's most kindly men. A scroll upon his grave in Preston Cemetery declares him to have been a great moral and social reformer during his ninety-one years on earth. Besides his great work with the Temperance Society, he was a very significant publisher, starting the *Preston Guardian* newspaper and *The Struggle*, a publication that highlighted the plight of nineteenth-century Prestonians in poverty.

The name of Edmund Robert Harris is surely etched forever into Preston's history. The son of a vicar of Preston, he showed his love for the town by leaving his family's fortune for the benefit of local people. An orphanage, an Institute for Knowledge and of course the free library, art gallery and museum were all to bear the Harris name

thanks to the solicitor's generous legacy. His fortune planted the university seed, gave hope to the orphan and enabled ordinary folk to read for free.

Also renowned for generosity was Sir Robert Charles Brown, who for sixty-four years was a Preston physician. Day trips for nurses and the costs of a new operating theatre were samples of the generosity of one who, in his latter years, local folk referred to as 'Preston's Grand Old Man'.

On Preston's Miller Park stands a statue of the 14th Earl of Derby; it is a reminder of a man who was to thrice hold the office of Prime Minister in the mid-nineteenth century. In a time when the Derby mansion stood on Church Street, the local voters rejected him, but his steely determination took Edward Geoffrey Stanley to the height of political matters.

Our skyline out Maudland way gives us a permanent reminder of the work of Joseph Aloysius Hansom, who was the architect and inspiration behind the building of St Walburge's Church with its magnificent spire. He spent some twenty years of his busy life in our town, and buildings in Liverpool, Hull and Birmingham are further testimony to his talent. Throw in the Hansom Cab, which he patented in 1834, and you have a measure of the man.

For architecture in our city, few could have a greater claim than James Hibbert, a former Mayor of Preston who earned much praise after building the Fishergate Baptist Chapel. So much so that the building of the Harris Museum in the Market Place was entrusted to his care and, after a decade of dedication, it became Preston's pride.

Builder John Turner, who was born in Havelock Street in Preston back in 1876, started in a humble way, repairing brickwork on a property in Inkerman Street. From that beginning he developed a business along with his three sons, being responsible for various landmark buildings in the town: the Guild Hall, Moor Lane Telephone Exchange, Preston Magistrates' Court and the ring road – all helping to shape the Preston of today.

Another local architect – of the more recent past – to earn deserved praise was Sir George Grenfell Baines, the founder of Preston-based Building Design Partnership. With contracts for universities, libraries, hospitals and numerous other buildings, his company was soon employing hundreds of people locally.

Preston folk also made numerous developments to the field of transport. Harold Bridges, the son of a Warton gamekeeper, became known as Preston's Mr Transport as he built a vast motor-haulage empire with over 100 vehicles and 400 employees. His company was taken over by a national enterprise in the mid-1960s and, in the years that followed, he was a generous benefactor for many charitable trusts.

Roland Beaumont joined English Electric in Preston in 1947 as Chief Test Pilot as the world's first jet bomber was being developed. He was soon taking the Canberra on its maiden flight, and down the years was at the controls of numerous pioneering aircraft. In all, his flying career lasted forty years; he was the first Briton to reach true supersonic flight, travelling at twice the speed of sound in a Lightning prototype.

When walking down Winckley Square, you may notice a commemorative stone embedded in an office wall. It reads simply: 'JT 1863–1931'. It is a reminder of accountant James Todd, who expanded his business interests worldwide. Motor

companies and aircraft suppliers were amongst his portfolio, and his last request was that his ashes be placed in the office wall behind the stone.

In eighteenth-century England, the role of Town Clerk was important; there was one in every borough and Richard Palmer served Preston for over fifty years. His stint began in 1801 and ended with his death in 1852, when he was aged seventy-eight – at which time he was the oldest Town Clerk in England.

Sir Harry Cartmell is a Preston knight worthy of consideration. Throughout the years of the First World War, he was at the helm of Preston's civic matters as Mayor of Preston. Under his guidance, local folk played their part in the war effort, enlisting in their thousands to bolster the soldiers needed to fight at the front. His book, entitled *For Remembrance*, offered fascinating insight into his war work. He was on hand to take the salute as the regiments departed, and on hand to welcome them back home. Another local hero of those war years was Private William Henry Young, whose bravery on the battlefield earned him a Victoria Cross. He was hailed a 'conquering hero' when he returned to town but, tragically, he died in the operating theatre before he could collect his award.

Jesuit missionary Revd Joseph 'Daddy' Dunn was instrumental in the building of the chapel and school for St Wilfred's; he also found time to inspire the formation of the Preston Gas Co. in 1815. His fundraising earned him the tag 'best beggar in town'.

When talking of church builders, the Revd Roger Carus Wilson is owed a debt of gratitude by Preston folk. St Peter's, St Paul's, St Thomas's, St Mary's and Christ Church were all erected during his years as the vicar of Preston. The quality of the buildings is reflected in their preservation long after the congregations dwindled.

Let's not neglect our poets either, who earned fame far and wide. Robert Service from Christian Road made his name abroad; his travels to the Yukon in gold rush days earned him worldwide fame as the 'Bard of the Yukon'. Francis Thompson, a poet born in Winckley Street, wooed the nation with the brilliant lyrics in his 'Hounds of Heaven'. Ill health dogged his latter days, which were spent in London, but his roots were firmly planted in Preston.

The work of Preston's artists is also still treasured, the eighteenth-century art of Arthur William Devis and his Preston-born sons being much admired. The father was a prolific painter; his eldest son Arthur, said to have a striking resemblance to Bonnie Prince Charlie, painted many a landscape too, and half-brother Anthony contributed numerous drawings and sketches to the family's collection.

Towards the end of the nineteenth century, Edwin Beattie produced a series of watercolours and sketches for which the city will be forever grateful. His work reminds us how the old town used to be. No fortune ever came his way and in his latter days he'd sketch buildings for a glass of ale or two.

Long admired is the statue of Robert Peel in Winckley Square, the work of local sculptor Thomas Duckett. His talent with mallet and chisel was unsurpassed, and in Preston Cemetery there are many examples of his fine work.

When one talks of entertaining the public then Hugh Rain, who was professionally known as Will Onda, had few equals locally. He was a pioneer in the early days of the cinema after his acrobatic stage career ended following an accident. He set up his own

Preston film company, with royal visits, Preston Guild and football matches all being recorded by him. The Picturedome and the Princes were amongst the places crowded to watch the early films that this prominent town councillor provided. His productions were in black and white but his life was very colourful.

These days Prestonians take pride in the exploits of film animator Nick Park, a local lad who found his creative ability, coupled with a Preston education, was enough to earn numerous Oscars. The creation of Wallace and Gromit took him to the top of his profession and he continues to astound and entertain with his character creations.

Alfred Aloysius Horn, who spent his early years down St Ignatius Square, took the literary world by storm in the 1920s when the tales of his life as a trader on the West Coast of Africa were published. A Hollywood film, *Trader Horn*, was even made to chronicle the old man's life of adventure, trading in ivory and rubber.

Likewise, Angela Brazil, who was born in West Cliff Terrace, earned recognition for her literary works. Her schoolgirl adventures, including *Schoolgirl Kitty* and *The Fortunes of Philippa*, were a must for thousands of teenage devotees in the early years of the twentieth century.

Preston-born Albert Edward Calvert earned fame when he became known throughout the world as 'The Man with the Golden Trumpet'. For Eddie Calvert, who had started life in the Preston Silver Band, there was chart success as he recorded 'Oh, Mein Pappa', a tune that was number one in the UK chart in December 1953 and sold over a million copies in America.

On the sporting front we have, at times, excelled and of course the legendary Invincibles brought fame for Preston and their beloved North End. At the helm in Preston's all-conquering days was William Sudell, a local mill manager, whose passion for football led him to recruit the first champions of the Football League. Amongst those brought to Deepdale by him were Jimmy Ross and Johnny Goodall, top strikers of the early days.

Then there is the Preston plumber Sir Tom Finney, who earned 'living legend' status for his sporting achievements. His career blossomed after the Second World War, and for both club and country he was

Alfred Aloysius Horn was an African adventurer from St Ignatius Square.

an inspiration. Twice named 'Footballer of the Year', his skill and sportsmanship were second to none. The Sir Tom Finney Stand is testimony to the high regard with which he is held.

Andrew Flintoff, the former Lancashire and England cricketer, was born in Preston in 1977. In 2005 he was named 'player of the series' as England overcame Australia to win the Ashes. He played in seventy-nine test matches, scoring 3,845 runs and taking 226 wickets.

For endurance, few could ever compare with Tom Benson, whose record breaking circuits of Moor Park made him the World Champion of long distance non-stop walking. His performance of 1984 – walking over 400 miles in 155 hours – was recognised with the naming of Tom Benson Way.

So Preston has its share of benefactors, businessmen, entertainers, artists, sportsmen and heroes, but Robert Service had his own opinion of who contributed most to the welfare of his birthplace, and indeed the world, with this verse from his poem 'The Ordinary Man':

We plug away and make no fuss,
Our feats are never crowned;
And yet it's common coves like us
Who make the world go round.
And as we steer a steady course
By God's predestined plan,
Hats off to that almighty Force
The Ordinary Man.

2

THE FIRST CITIZENS OF OUR CITY

Arguments will often rage, these days, before the annual choice of Mayor of Preston is finalised. Fortunately, the prestigious role as first citizen is still sought with enthusiasm, the successful candidate having their name added to a list dating back to Aubrey, son of Robert, in 1327.

Sadly, the early records are incomplete, coming as they do from the Herald's College and the manuscripts of Dr Kuerden. Only from the middle of the seventeenth century are the lists of mayors and bailiffs held by the Corporation of Preston. The Municipal Reform Act of 1835 abolished the office of bailiff in those days when the municipal year ran from November to November.

Adam Morte was elected to be Mayor in 1642 but declined to take the office and was consequently fined 100 marks. By the following February, when the Parliamentarians stormed Preston, he chose to defend the Royalist cause and, along with his son, fought bravely before being slain. A year later, the Mayor William Cottam and his bailiffs were seized by Prince Rupert, who accused them of apathy towards the Royalist cause and imprisoned them for three months at Skipton Castle.

Not surprisingly, a number of familiar local names are amongst those listed in the records as holding the high-ranking position. The name Bannister (or Banestres) appeared on thirty-one occasions between 1345 and 1664. In 1617, the Mayor was Thomas Banastre and Taylor, a respectable poet of the day who lodged in the town, had this to say:

Unto my wayward lodgings often did repair,
Kind Master Thomas Banestre the Mayor,
Who is of worship and good respect
And in his charge discreet and circumspect;
For I protest to God I never saw
A town more wisely governed by the law.

The Grimshaws, a father and two sons, also filled the role with dignity. So much so that this noble family had a representative wearing the robes of office thirteen times. The youngest son, Nicholas Grimshaw, a man highly regarded in the legal profession,

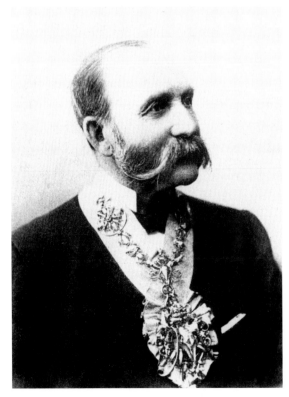

was to be seven times Mayor of Preston, including twice as Guild Mayor in 1802 and 1822. Perhaps more Grimshaws would have filled the role had his two sons, Nicholas and George Henry, not drowned in a boating accident on the River Ribble in 1822.

Many holders of the office had great influence in the town, and it is no surprise that Samuel Horrocks and his son both wore the robes of office, as did Thomas Miller, another member of that cotton dynasty. Not forgetting other influential cotton kings, such as John Goodair and his soldier son William Henry, Charles Roger Jacson, Thomas German and generations of the Paley family.

James Burrow was thrice selected as Mayor of Preston.

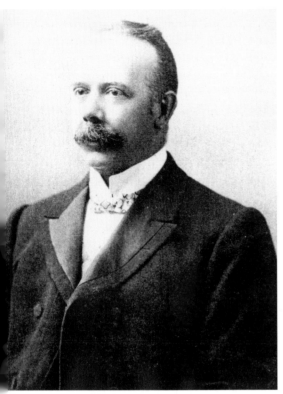

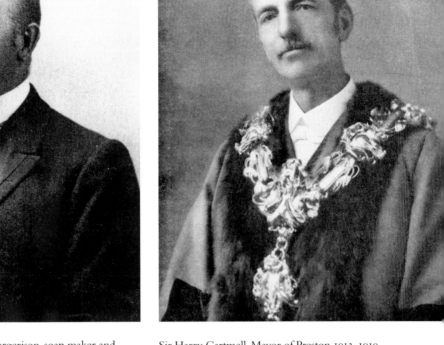

William McKune Margerison, soap maker and Mayor of Preston.

Sir Harry Cartmell, Mayor of Preston 1913-1919.

The office certainly seemed to run in families; there were the Humber brothers linked to the corn trade, the Pedders with their banking links, three generations of the Park family, and the brothers Myres who held the mayoral robes five times between them. The most enterprising nineteenth-century folk also had their years in the spotlight, such as William Henry Woods of tobacco manufacture; the thrice-selected James Burrow, gunsmith of the town; the architect of the Harris Museum, James Hibbert; and coal merchant John Rawcliffe.

Early in the twentieth century, leather merchant William Henry Ord spent two successive years as the Mayor, combining his duties with those as chairman of Preston North End and president of Preston Cycling Club. Another to serve for a couple of years was Thomas Parkinson, the man with the biscuit factory, while the soap manufacturing Margerisons had William McKune Margerison carrying out the duties for two years. The man destined to have the longest unbroken spell as Mayor of Preston was Harry Cartmell, who was on hand as the First World War broke out and remained until hostilities were over. A knighthood followed for six long years of civic service.

In 1925, the president of Preston Weavers Association, Jeremiah Woolley, became the first Labour politician to become Mayor of Preston and, in 1933, the ladies of Preston rejoiced when doctor's wife Avice Pimblett became the first woman elected to the role.

Four years later, Oswald Aloysius Goodier broke traditions that went back to the Reformation when he became the first Roman Catholic duly elected. After agreement was reached, a civic visit to the parish church was no longer deemed necessary.

In the decades that followed, a succession of local councillors were honoured for their contribution to the town's affairs. William Beckett, who worked on the railways, was twice Mayor of Preston during a council career lasting forty-four years, ending in 1973. In 1958, the Labour party rejoiced when Mary Ann Wignall, a long-serving party activist, became the first woman to represent them as Mayor. Twelve months later it was celebration time for both the Labour Party and the Roman Catholics as ex-bus conductress Florrie Hoskins wore the mayoral chain. Local postal worker Cyril Evan Molyneux was rewarded for a decade of service and was on hand to open the new GPO Sorting Office on West Cliff in 1964.

In 1975, after rejecting the opportunity on a number of previous occasions, the long-serving Robert Weir, a staunch Labour councillor, celebrated twenty-five years on the Town Council by accepting the appointment. Next up was Harold Parker, who began his political career by protesting against local bus routes and ended up as Guild Mayor in 1992. Local draper Joseph Hood, who took over in 1977, would wear the mayoral robes twice during his long career, as indeed did Ian Hall, the prominent Labour councillor.

Tory ladies dominated the middle of the next decade as Dorothy Chaloner, Nancy Taylor and Joan Ainscough followed each other onto the mayoral role in successive years. Throughout the post-war years, apart from two Independents being selected as Mayor, the honour was shared by Labour and Conservative councillors. All that changed, however, in 1996, when Ron Marshall, who had spent twenty years fighting the cause of the Liberal Democrats, took over to end a spell of Labour domination.

At the turn of the century, the title of Millennium Mayor was bestowed on Geoff Swarbrick and, a couple of years later, Jonathan Saksena wore the mayoral robes when the Queen visited to confirm City status on proud Preston. The year 2010 saw the popular Albert Richardson join the list of those who wore the robes of office a second time.

Whoever wears the mayoral chain around their shoulders in the future will step into a role that has been cherished by many, and has played an important part in shaping the future of Preston.

3

FREEMEN FIT FOR A CITY

In 2005, the Mayor of Preston led the campaign that saw Preston-born cricketer Andrew Flintoff made an Honorary Freeman of Preston; the England cricketer was delighted to receive the distinguished title.

The title of Honorary Freeman of Preston is not given freely by the City of Preston, but is an honour bestowed upon the citizens or institutions deemed most worthy. It should not be confused with the title Freeman, which the Guild Burgesses lay claim to every twenty years and is generally a hereditary title, although each Preston Guild sees the addition of a few more names. In fact, at the Guild of 1992 the total number of burgesses was over 800, including – for the first time on an equal footing – some 274 women.

According to the Charter of Henry II, the old Freeman of the Borough had the right to buy or sell goods without the payment of tolls, buy goods before those who are not freemen, graze cattle and geese free of charge on the Marsh, cross old Penwortham Bridge without the payment of a toll, and send their sons to the grammar school for payment of two guineas per year.

The Honorary Freeman gets no such material advantages, but has the pride and satisfaction of knowing he has the respect of the community. In line with the old Local Government Act, passed in the late nineteenth century, an Honorary Freeman is chosen after the passing of a resolution put before the City Council, of whom two thirds must be in favour.

The first Honorary Freeman elected thus was the Rt Hon. Frederick Arthur Stanley, Earl of Derby, who was Guild Mayor in 1902 and was made an Honorary Freeman in November of that year in recognition of his contribution to the town. Five years later, solicitor Alderman John Forshaw, son of an innkeeper, was given the honour in recognition of the fact that he had served on the Town Council for thirty-four years, during which time he had been Mayor of the Borough and given loyal service to the town of his birth.

In 1910, the honour was given to Dr Robert Charles Brown, a fitting accolade for a man who would later receive a knighthood for his medical work. Born in Winckley Square, Preston in 1836, he was to spend sixty-four years as a doctor in the town, working initially as a house surgeon at the Preston Dispensary and later on at the Preston Royal Infirmary.

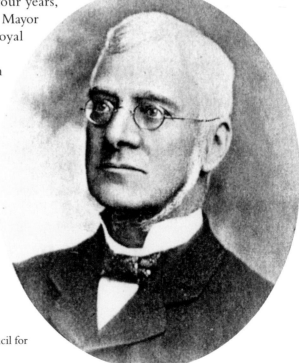

John Forshaw served on Preston Council for thirty-four years.

A lifelong bachelor, he became known as Preston's 'Grand Old Man'. He died in Guild Year 1922 at the age of eighty-six, being remembered as a benevolent gentleman.

At the start of the First World War the Mayor of Preston was Harry Cartmell and, along with his wife, he served the people of the town throughout the war years, enabling the borough to enjoy the benefits of civic continuity throughout the trying times. In October 1919, with peace restored, the Manchester-born alderman and his wife were rewarded for their efforts by being added to the list of Freemen of the Borough; a knighthood followed later for Sir Harry and a delighted Lady Cartmell.

Two years later, in 1921, the Liberal politician Alderman Crook Hamilton was added to the roll of honour in recognition of his service since 1891 on the Preston Town Council. Born in Stanley Terrace, Preston, he was the son of a silk merchant and draper who had a business in the Market Place. A member of Fishergate Baptist Church, he had twice declined the mayoralty of the town on religious grounds, so his elevation to the position of Freeman was seen as a fitting tribute.

The next recipient of the honour was Preston-born Alfred Howarth who, at the age of twelve, had gone to work in the Town Clerk's department at Preston Town Hall. In 1907 he was elected Town Clerk after twenty-seven years' service in the department and, in 1926, after almost twenty years in that role, a resolution was passed to confer

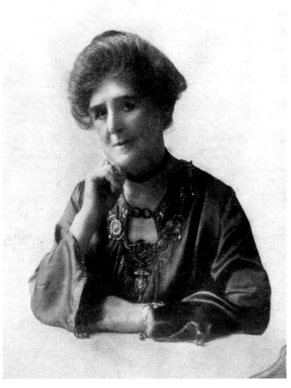

Lady Cartmell was made a Freeman after the
First World War.

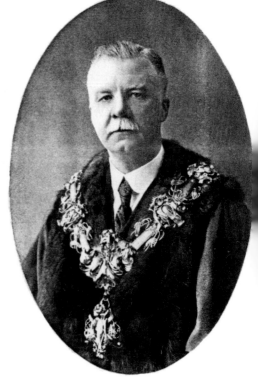

Henry Astley Bell, former Guild Mayor,
became a Freeman in 1935.

the Honorary Freedom of the Borough on a man who would later be knighted for his service, which he carried out with great dignity and responsibility.

The Guild Mayor of Preston in 1922 was Henry Astley Bell, an Accrington-born man who was a power in the Preston cotton industry. He was a deeply respected figure on the Town Council, becoming an alderman and having the Freedom of the Borough bestowed upon him in 1935.

Three years later, in April 1938, the town added two more names to the distinguished list when Alderman Frederick Matthews and the then Earl of Derby, the Rt Hon. Edward George Villiers, were awarded the honour at a ceremony in the Guild Hall. Lord Derby was rewarded for his great service to Lancashire and followed in the footsteps of his father, who had been honoured in 1902. Alderman Matthews was rewarded for his dedicated service to the town and in particular his contribution to the Parks Department.

Not until April 1949, with the wars behind them, did the Town Council turn once more to the matter of honouring its distinguished servants. On this occasion, three of the town's Aldermen were honoured with the Freedom of the Borough. Avice Pimblett was thought worthy after twenty-eight years as a Town Councillor, during which time she had become the first woman to don the mayoral robes. The other recipients were Richard Durham and Richard Crane Pye, the former having served his native town for thirty-four years and the latter having been a councillor since 1928.

In 1952, the Guild Mayor was Preston-born John James Ward, who had been on the Town Council from 1928 until 1945, from which time he concentrated on his role as a magistrate. His distinguished service to the town and his prominent role in the Guild celebrations earned him a place on the roll of honour later in the year.

It was another twelve years before Preston deemed another person suitable for the honour, when Alderman William Beckett and former Alderman Frank Jamieson were made Honorary Freemen of the Borough. Preston-born Beckett, a former railway worker and military medal holder for gallantry, had given thirty-five years' service to the Town Council and been an active trade unionist. Jamieson was rewarded for his contribution to the transport system of Preston, having spent almost thirty years as Transport Chairman.

In 1979, the Town Council broke with tradition when they recognised the achievements of one of the town's favourite sons and bestowed the honour upon Tom Finney – almost two decades after his distinguished football career had ended. With his knighthood still some years away, the Town Council were keen to acknowledge his contribution to the town during his international football career, and in his charitable and civic contribution after his retirement.

In June 1984, former cotton mill worker Catherine Sharples, aged seventy-four, became the first woman for thirty-five years to receive the honour. The docker's daughter had been on the Town Council for almost thirty years and had been a key figure in the founding of St Catherine's Hospice.

In Guild Year 1992 thoughts once more turned to civic honour, and by resolution of the Council the honour was given to three prominent local leaders. The Guild

Mayor elect Harold Parker, who had been leader of the Labour group for a decade, was deemed worthy, along with fellow Socialist and former Mayor Ian Whyte Hall. Also chosen was long-serving Conservative party leader Joseph Hood, who had been on the Town Council from 1969 and was Mayor of the town for the first time in 1977.

Five years on and the town honoured another of its favourite sons when Nicholas Park, the world-famous animator, was made an Honorary Freeman of the Borough in October 1997 to mark his achievements with the comic creations Wallace and Gromit. With three Academy Awards to his name at the time, the former Preston schoolboy had brought fame to his home town.

In addition to honouring individuals, the City of Preston has also in recent times granted three organisations the honour. In November 1992, the honour went to the 14th/20th Hussars Regiment, a year later the parish church of St John was similarly honoured, and in March 2000 the University of Central Lancashire was added to the distinguished list.

With a distinguished cricketer of local birth the latest name now on the list, the City Council will be debating who next will receive such an honour.

<div align="center">

———

4

</div>

MAKING A LASTING IMPRESSION

Who is deserving of a statue these days? Prestonians might argue in favour of Sir Tom Finney, the pride of Preston. Fortunately that particular matter was dealt with in his eightieth year at his spiritual home, Deepdale.

Looking around Preston there are only a few statues on display in the city's streets, and most of them go unnoticed as we hurriedly pass by. One of the most prominent is a more recent addition: the sculpture that depicts the Lune Street Riot of 13 August 1842. Erected outside the old Corn Exchange building, it depicts the soldiers of the Queen firing upon the rioting mill workers.

If you have ever wondered what the Revd Robert Harris, the former vicar of St George's, looked like, pay a visit to the nearby church where you can view a marble figure that is a likeness of the man himself. Sixty-four years a vicar and the father of Preston's great benefactor, Edmund Robert Harris – he of museum generosity – what greater monument is there?

In the Market Square stands the Cenotaph, unveiled in 1925 to honour the 2,000 local men who perished in the First World War. Its tapered column and stone tableau of grieving victory are a reminder of the human cost of battle. Many local parishes erected monuments of their own to victims of the First World War, a typical example being the one on Meadow Street, within the grounds of St Ignatius' Church (a parish that lost over 200 souls in the great conflict). Another striking memorial stands in the

Left: The statue of Sir Tom Finney at Deepdale.

Below: A memorial to the Lune Street Riot of August 1842.

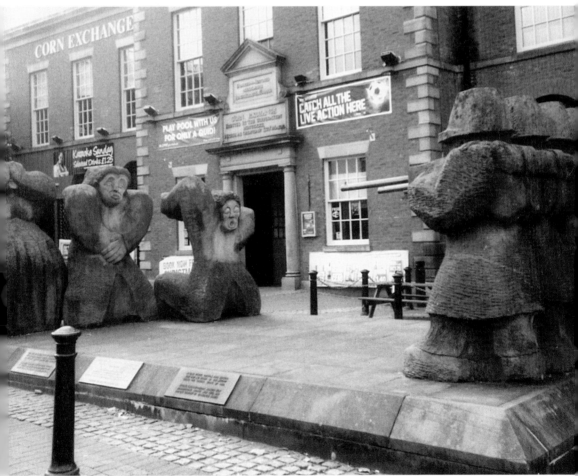

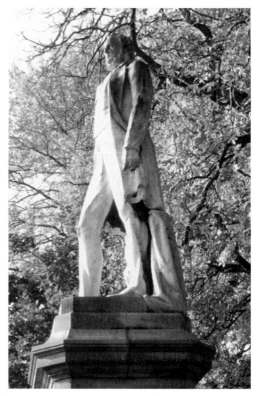

The Earl of Derby's statue looks out over Miller Park.

grounds of the old Harris Orphanage and takes the form of a youthful soldier; it was erected to remember the former orphans killed in the war.

Preston is blessed with magnificent parklands, and amid the well-maintained slopes of Miller Park is the statue of a man thrice Prime Minister of our sovereign land. This statue on the Derby Terrace of Edward Stanley, the fourteenth Earl of Derby, is a reminder of a man once rejected by the voters of Preston. He didn't bear a grudge, and donated £5,000 to the Lancashire poor during the Cotton Famine of the 1860s. The monument, standing over 11ft tall, is mounted on a 15ft pedestal made from Aberdeen granite. A fair proportion of its £2,500 cost came from a workers' penny subscription. In the middle of the fountain that lies at the foot of the terraced steps leading to the statue are four sculptured figures, representing Earth, Air, Fire and Water, all crafted from Longridge Stone.

Over in Avenham Park is a reminder of our brave soldiers who fought in the Boer War, this memorial being moved from the Market Square when the present-day Cenotaph was built. Also in this park, within the rock gardens, is a tablet that tells us of the exploits of the Mormons, who baptised the newly converted in the nearby River Ribble in 1837. On nearby Avenham Lane is a recent addition to our historical reminders. A giant needle and plaque records that Simpson's Gold Thread Works operated from that area from 1839 for over 150 years.

If you pass along Winckley Street you will see, fixed to the wall, a bronze plaque with a likeness of Preston's famous poet, Francis Thompson. He was born in that very house in 1859 and made his mark on English poetry.

If you should enter Winckley Square from Cross Street, glance upwards to see the work of our local sculptor Thomas Duckett, whose hands chiselled out of Lancashire limestone a likeness of Sir Robert Peel. This statue to another former Prime Minister was unveiled in 1852, a memorial to a statesman who had died following a horse riding accident.

In Preston Cemetery you will also find many statues and monuments to admire. Not far from the entrance is the Cross of Sacrifice, which was erected in 1920 to remind us of those who sacrificed their lives in the First World War. The last resting

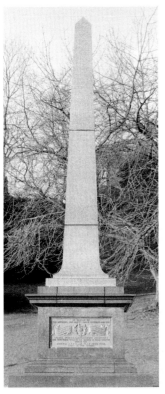

place of war hero Private William Young is marked with a white cross, and is mounted on a plinth which records his bravery in the Great War. His well-earned Victoria Cross was presented to his widow after his death in the operating theatre.

Also in the cemetery is a striking and imposing monument to the Temperance Pioneers of old Preston, whose efforts are recorded for all to admire. The monument stands proudly amongst the graves of those whose lives the founding fathers worked to better, proclaiming, 'He who drinks the water of the Lord shall never thirst'. Fittingly, the great man Joseph Livesey – who led those Temperance campaigners with such vigour – has an inscribed scroll upon his grave. This includes the highest praise for the moral reformer, who was a friend to the poor.

Thomas Duckett, our much admired sculptor, had the foresight to chisel his own distinguished features into the gravestone above his final humble resting place. On the reverse side is the face of his second wife, Winifred.

Also to be admired is the magnificent Celtic Cross beneath which Annie Kelly, a laundry maid, is buried. Murdered by her sweetheart when she refused to elope with him, Miss Kelly had her memorial paid for by public subscription. She died in defence of her virtue, proclaims the inscription.

In more recent times, the giant wooden figure of a man representing Water was added to the scene, overlooking the new Lancaster Canal Link – alas, it seems wood is not quite as robust as other materials and it is now removed for repairs. Another modern addition is the large stone boulder placed in Moor Park to remind us of the exploits of marathon walking champion Tom Benson.

Despite all these fascinating statues and memorials, the ones that are often most talked about are those that once perched on top of the old Port Admiral public house, which was demolished in the rush to create our ring road through the city. Lord Nelson was one, Napoleon was there too, and the third was that of a naked woman with her hand discreetly placed; let modesty prevail.

In the words of one nineteenth-century hopeful:

Make me a statue too
Let it stand tallest of them all
Placed high upon the City wall
So those that gaze
Will know I've been there too.

IN THE FOOTSTEPS OF THE FRIARS

At the present time, work is in progress to rebuild a further section of a somewhat neglected stretch of Friargate, much to locals' delight. Friargate is, after all, one of the city's most ancient thoroughfares, with the lower end suffering for the last few decades after the building of Ringway effectively sliced it in two.

Back in the thirteenth century, when the Grey Friar (Franciscan) monks had their friary built in the area now known as Ladywell Street, they would walk up to the Market Square to preach and their well-worn path marked the route they trod. When houses were developed along this path that led from the town centre to the very gates of the monastery, it became known as Friargate. In those days, there were fields behind the houses and the way to the friary was very narrow. In fact, over 350 years ago, in 1655, an order by the Court Leet directed that 'occupiers of land in the friars lane shall lopp and cut down their hedges so that carts and carriages may pass'. By this time the friars had long gone, and their building was used as a country prison for the reform of vagabonds, beggars and thieves with hard labour, sparse diet and whipping on the agenda.

Advance to 1715 and Friargate was the scene of a bitter struggle during the first Jacobite rebellion. A detachment of Highlanders put up barriers near the bottom of Friargate, but they had barely fortified their defences when the government troops were upon them. The first attacks were repelled but, later on that November day, the government troops burned all the barns and buildings leading to the barricade in preparation for a further assault the next day. By early morning, the Royalist troops had been reinforced with soldiers from Clitheroe under the guidance of General Carpenter and the rebels were obliged to quit. The brave Highlanders lay down their arms and walked up Friargate to the Market Square for a costly surrender, with up to seventy of them being hanged at Gallows Hill (where the Church of the English Martyrs now stands) less than two months later.

In 1761, the Roman Catholics of the town were somewhat excited at the opening of the chapel of St Mary's on the western side of Friargate Brow. A reflection of the times, however, is the fact that it was hidden away from the public glare, up a flight of steps and through an arch. Seven years later, the Catholics' concerns were realised when,

Grey Friars arrived in Preston in the thirteenth century.

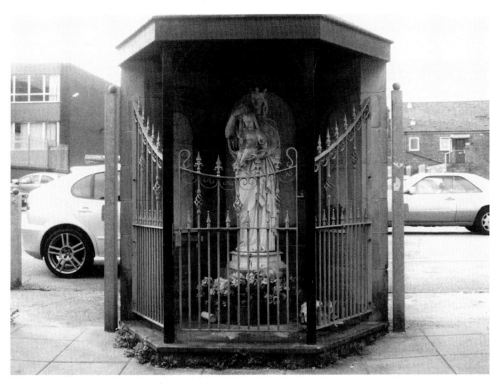

A reminder of St Mary's Church in the Friargate car park.

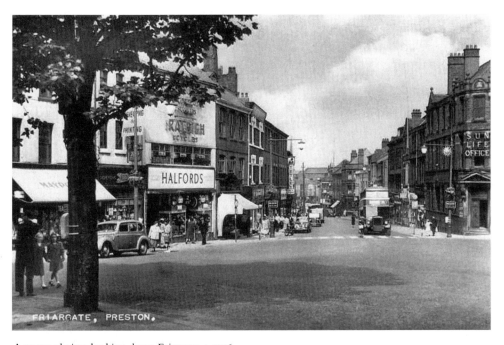

A postcard view looking down Friargate, *c.* 1956.

during an election riot, a rampaging mob burnt the chapel to the ground with the grief-stricken priest forced to flee. Of course, the faithful rebuilt their place of worship and the site was only recently given up to tarmac and parking tickets.

By the middle of the nineteenth century, Friargate was described in a report commissioned for the *Builder Magazine* as 'a long, old fashioned, winding thoroughfare of second and third rate shops to supply the wants and needs of the dwellers of the innumerable courts and alleys with which it intersects'. The article continued:

> The rear of many of the premises are a horrible mass of corruption and, in fact, forcing pits for fever. Some of the buildings like the Waterloo Inn being whitewashed and showy about the entrance yet look behind into Hardman's Yard and you will find a monster midden pit with privies at each end and the clothes of the poor hanging out to dry over this disgusting pit. Peelings, slops and tea leaves all strewn about the yard and piles of refuse left to rot.

Things had certainly got better by the late nineteenth century, at least in the eyes of the town's drinkers – after all, take a trip along Friargate and you could quench your thirst at no less than twenty public houses. At this period, in 1895, the original George Hotel was knocked down, along with the Virgin's Inn on Anchor Wiend, to permit the widening of Friargate at its Cheapside end.

With much better access, Friargate was becoming a significant part of the Preston landscape and, in January 1905, there was much excitement when the Royal Hippodrome opened adjacent to that great survivor the Black Horse public house, just beyond Orchard Street. This theatre was to play a significant part in Preston's entertainment for over half a century, with many of the nation's finest taking to the stage and the annual pantomimes putting up 'full house' notices. Alas this theatre, like many more, hit on hard times with the advance of the television age and was closed in 1957, being knocked down two years later to make way for the C&A department store, which itself was revamped in recent times to be replaced by the present-day Wilkinson's store.

Amongst the great Victorian survivors of Friargate are the Halewood's Bookstores – one next to the now extended Black Bull public house and the other further along the same stretch of road. With the sign 'Temple of the Muses', they carry a wealth of antiquarian books, including many steeped in Preston's history. The old Black Bull itself, the Dog & Partridge, the Sun Hotel and the Lamb & Packet still remain from the Victorian era, and even these days the old Ropers Boys' School next to the Sun Hotel is a place of drinking and dancing. What Alderman William Bryham Roper, twice Mayor of Preston and a staunch Church of England stalwart, would have thought of it all we will never know.

However, there is no Boars Head now, nor Roast Beef Inn, Crown & Thistle, Butchers Arms or indeed Waterloo Inn to remind us of those bygone times. At least the coming of the Grey Friars public house on the site of the Old Britannia inn serves as a reminder of the path those monks of old once trod so devoutly.

Of course, these days Friargate remains an interesting place to wander; along the stretch to the Ringway is a modern, almost traffic-free, thoroughfare with an

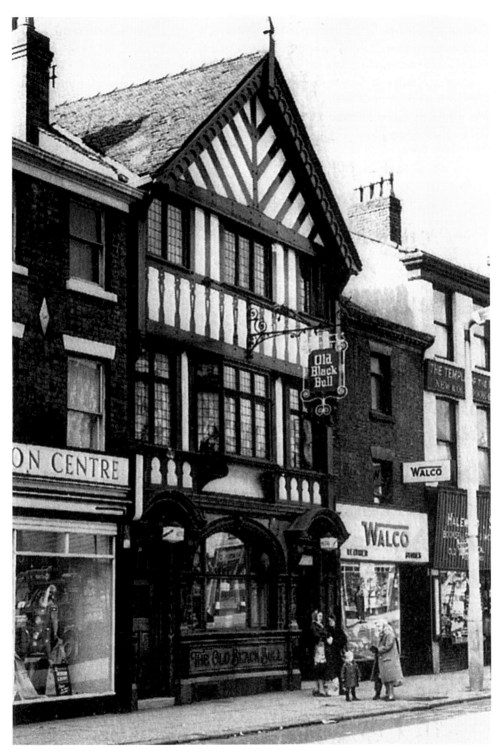

The Old Black Bull around 1969, before the Ringway arrived and it became detached from the shops to its right.

intriguing variety of premises. Cafés and burger bars mingle with clothes shops, opticians, travel agents and record sellers to give the appearance of a modern-day high street. From the Ringway to the Fylde Road roundabout you can buy flowers, have your hair cut, purchase a property, buy the latest hi-fi equipment, dine in a fashionable restaurant or even have your naval pierced.

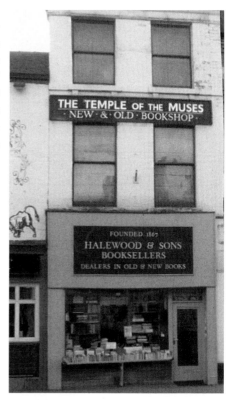

Right: Halewood & Sons Booksellers.

Below: The Lamb & Packet.

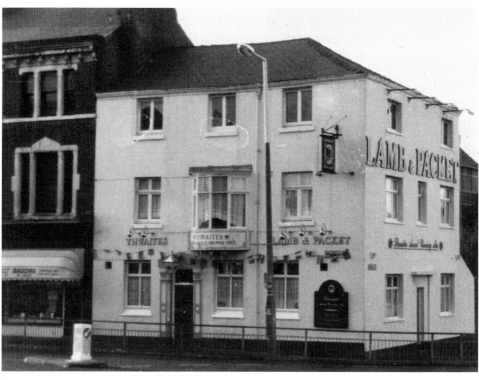

IN SEARCH OF PRESTON'S HIGH STREET

The High Street is, in many cases, home to the leading retailers and businesses in any given town or city. Visit Preston, however, and although we have our Friargate and Fishergate, you would have to search hard to come upon the High Street.

Curiosity prevailing, I delved into the annals of our history to find out what became of our High Street. On Baines Map of 1824 it is clearly marked as a significant thoroughfare, stretching from Tithebarn Street down to Starch House Square – although its geographical location is someway away from the leading thoroughfares of Fishergate/Church Street and Friargate.

One nineteenth-century resident of Preston High Street was James Green, who was born there, and in his later years recalled how at the tender age of nine he left school and commenced hand-loom weaving with his father in the cellar of their home. He remembered that, as a youngster, there were only two or three streets northward of the High Street, and both Saul Street and Lawson Street were only partly developed. Only in later years was Lancaster Road built across the High Street, with four houses on either side being demolished to create the thoroughfare. He recalled how the lead spouts on the houses had the date 1797 etched on them, and assumed that the bulk of houses were built around that date.

Starch House Square.

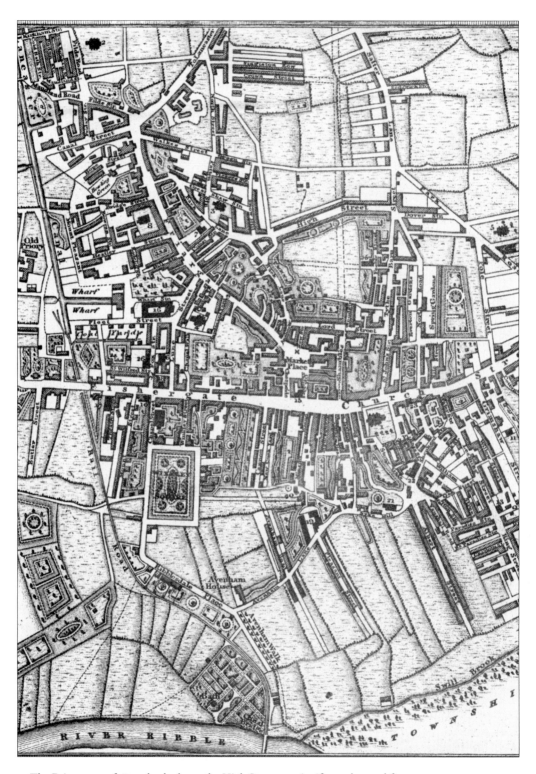

The Baines map of 1824 clearly shows the High Street as a significant thoroughfare.

It was the era when the cotton industry was attracting folk to the town and the great houses on Winckley Square were being erected. The deeds of two houses on the north side of the High Street show that a weaver by the name of James Snape purchased them, along with their rear garden plots, for the total sum of £210. At that time, weaving from cellars was regarded as a profitable business.

In the year 1861, a representative of the *Builder* publication visited Preston and was highly critical of this cotton-factory town, with the High Street coming in for a certain amount of criticism, as the following extract indicates:

> The High Street is a row of poor houses about one-eighth of a mile long, with small back yards; and at the back of these a huge sewer discharges itself on to the surface, and forms a wide bog, the whole length of the row of houses. The solid filth from this overflows the outlets and blocks up the privies of the High Street residents. One resident remarking that it had been nothing but a bog for over nine years, ever since Pender and Leaver had begun to boil tripe at the top of the street, and discharged the contents to flow in tributary streams. The back windows of the houses overlook a large plot of land known by tradition as the Orchard, which is partly built upon and partly used as a playground by ruffians. The ground of the Orchard is a surface of thick, black, hard mud on which a tribe of pigs can be seen.

Not, it would seem, an ideal place to live. Of course, things improved as the Victorian era gathered momentum and the Orchard became the site of the Covered Market. Indeed, by 1910 the High Street was a fairly respectable thoroughfare with a couple

Saul Street Baths, now gone from the local landscape.

Preston's High Street, looking eastwards, *c.* 1956.

of public houses – the Painters Arms at the junction with Lawson Street, and the Ormskirk Tavern. A couple of premises had been turned into lodging houses and a handful were occupied by shopkeepers. Trades people of all description resided there – chimneysweeps, wheelwrights, carters, porters, engineers, painters, fishmongers and even an ice cream seller, a crane driver and a clog maker.

Not surprisingly, the Germans didn't see fit to bomb our High Street in the Second World War and, when peace reigned once more, it was still a lot like it was in the early days of the twentieth century. The Painters Arms was still serving beer, the odd lodging house remained, and a few shopkeepers were still in business. Labourers, joiners, sign writers, gardeners and a baker all resided in the street and the Preston Cycle Club and Fruiterer's Social Club used High Street premises.

In July 1956, when Preston's first smokeless zone became a reality, the High Street was part of the northern boundary and an order was enforced to prohibit the emission of smoke. It was a time of great changes in the town, with slum clearance underway in many areas, and a decade later the proposed inner ring road plans spelt the death knell for most of Preston's High Street. Within a couple of years only a small section of the High Street remained, as the bulldozers moved in and turned it all to rubble.

What remains of our High Street today looks out over the busy ring road that sweeps past the new law courts – where Saul Street Baths once stood – before it splits Friargate in two, heading out of town. Two centuries on, the street sign is still visible and there are a couple of businesses operating from the place, but all traces of its former glory are buried beneath the concrete of our ring road. The High Street is the most common street name in the UK, with over 5,400 thoroughfares thus named, and, perhaps more by chance than anything else, part of our High Street still remains.

7

TITHEBARN – TIMES THEY ARE A-CHANGING

The signing of the original Tithebarn Agreement in 2005 was meant to herald an imminent regeneration of an area of Preston that has perhaps been neglected in recent times. It is a part of the city that has a long and colourful history, stretching back to the roots of civilisation. Alas, progress has been slow, but before more of Preston's history is swept away, let's glance back at this historical area.

Tithebarn Street has seen many changes during the lifetime of older Prestonians; indeed, it is a far cry from the days when thatch roofed cottages stood along it. Currently the street is home to the Preston bus station, which opened in 1969 on the site where Everton Gardens once stood with its humble terraced homes, many occupied by the firefighters employed at the fire station that occupied the space opposite Crooked Lane.

On the corner of that lane was the Princes Theatre, and further along Tithebarn Street were the Regent Ballroom, the Old Vicarage and the Kings Palace Theatre, all swept away with the coming of St John's Shopping Centre. We must not forget the old Ribble bus station which took pride of place before ambitious plans led to the building of the Guild Hall on its site, just in time for the Guild of 1972.

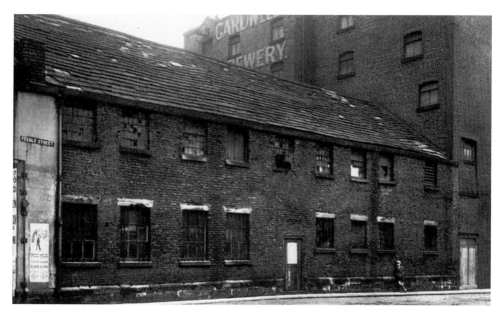

The old tithebarn on Feeble Street, c. 1937.

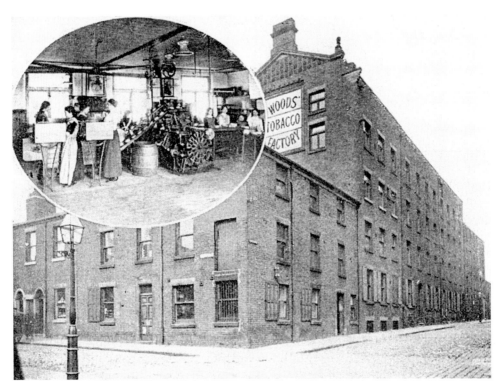

An advertisement for Woods' Tobacco Factory on Derby Street.

On the corner of Lord Street is the Tithebarn public house. This inn bears little resemblance to the old Waggon & Horses which stood there, named in recognition of the numerous blacksmiths who frequented the area. The Tithebarn itself existed in Feeble Street, not far from the Old Vicarage; over 70ft long, it remained relatively unchanged until it was demolished some three decades ago. Lord Street itself was at one time occupied by handsome family residences, which later became business premises as the corn trade flourished in the area. The name, no doubt, was a reminder of the influence of Lord Derby and his family, who had great connections with the town, as those other ancient thoroughfares of Lords Walk (once home to the Employment Exchange), Derby Street (where William Henry Woods had his tobacco factory), Stanley Street (which had an entrance to one of the Horrocks cotton mills) and Earl Street (with the old police station on the corner) suggest.

In the latter years of Queen Victoria's reign, one old-timer of the town, Richard Aughton, wrote of the Church Street he had known before she took to the throne. He remarked that the thoroughfare in his youth had been a thriving place. Opposite the bottom of Grimshaw Street had been the very large house known as Patten House, with large iron gates and a gravel path to its front, occupied occasionally by the Earl of Derby himself. Meanwhile, the old Town Hall, which in 1830 offered a view from the council chamber looking down Church Street and on to Friargate, held many a banquet with the councillors and their friends partaking of hot-spiced wine on the first Sunday

The 16th Earl of Derby kept a strong link with Preston.

Preston's old Town Hall, opened in 1782.

of every month. Of course, Church Street was very different then; the old parish church had a quick thorn hedge, some 5ft high, at its front along to Stoneygate, where there were also thatched cottages.

Mr Aughton recalled it being a busy place; the Dog Inn was noted for the number of carts that left there each day laden with folk wanting to travel to East Lancashire or to Lytham to bathe. Some 20 yards up from that inn was the old post office. The mail was carried by a coach with four horses, the driver and the guard resplendent in their red tunics, departing from or arriving at the Red Lion, Bull Hotel, Crown or Legs of Man. It would cost you half a crown to journey as far as Liverpool, and the driver expected a handsome tip too.

Where the Red Lion once held a prominent place, the government excise officers would meet; brick makers of the time were expected to pay duty on every brick they made and woe betide the fellow who tried to fiddle the figures. Just along from there was the Old Bank – run mainly by the Pedder family – which had a portico entrance on stone pillars. It was a fine building for its time; however, a century ago, in 1904, the Preston Saving Bank was erected on the site. Further down the street, Joseph Livesey was busy in his cheese warehouse, the upper rooms being used to print his many Temperance tracts and papers.

The great North Road, which began at the side of those buildings and stretched from Church Street through to Garstang Road, inspired historian Anthony Hewitson

to write the book *Northward* at the end of the nineteenth century. Of course, the Church Street that lives in the memory of today's older generation had the Palladium, Ritz, Odeon and Empire cinemas along its length – all of which fell victim to the age of the television. Its days as a major shopping thoroughfare are still very much remembered, as are the days when trams would journey along it.

It seems that there are even grand plans for our Covered Market, where an orchard once flourished. Its erection was not without troubles – with the first attempt ending in disaster when the roof collapsed in August 1870, leaving a tangled wreck of iron on the ground. It was completed successfully five years later when Thomas Allsup came to the rescue, and remains a source of pride for Prestonians even if it is a bit chilly on a winter's day.

Let's hope that the planners leave some reminders of bygone days – although, no matter what the bulldozers sweep from their path, generations of Preston folk will remember the days of old. Fortunately, history isn't purely about bricks and mortar but about the very people who shaped our city of today.

8

THOSE TAVERNS IN THE TOWN

According to the latest reports, the popularity of the public houses in Preston appears to be in decline. Regular news of closures is commonplace, no doubt causing concern to the devoted drinkers of our city. In reality it is only continuing a trend begun in late Victorian days, when Preston could claim to have no less than 460 public houses or beer houses within the old borough boundaries. The great demand for licensed premises was fuelled by the industrial developments in the town and the need for cotton operatives to quench their thirst after a day of toil. The inns were seen by many as the curse of the working folk, and great campaigners such as Joseph Livesey, the leader of the Temperance Movement, never tired from spreading the word of abstinence from alcoholic beverages.

The Matthew Brown brewing empire was developed in the middle of the nineteenth century from his flagship public house, the Anglers Inn in Pole Street. Indeed, the name Matthew Brown appeared over many a local public house which provided ale at a penny a pint and stayed open for twenty hours a day. He became famous as a brewer with a beer called 'Old Tom' that was supplied throughout the town and farther afield. The advertising board showed the face of a cat, highly coloured with sly, wide-open eyes and whiskers, with the slogan underneath 'Try Our Old Tom' – many did and went back for more.

Nostalgia seems to surface whenever a public house closes its doors and Preston's old inns are no exception. Those with memories reaching back before the Second World War will tell you of the Craven Heifer on North Road, noted for its home-brewed

ales. Along its length, such licensed premises as the Sir Walter Scott, the Queen's Hotel, the Hero of Vittoria, the Three Tuns, the Sitting Goose and the Apollo hoped to tempt the thirsty traveller. The stretch where maisonettes and industrial units now stand, once flanked by rows of terraced homes, had a Mill Tavern, Iron Duke, Old Royal George, New Royal George and a Lord Nelson on the corner of Sedgwick Street. There was also a New Inn, Garricks Head, Rose & Crown, Burns Hotel, Bay Horse Inn, Morning Star, Church Hotel and Commercial Inn, all just a short walk away for local folk in the neighbouring streets.

New Hall Lane, an area that developed as John Horrocks built his cotton empire, is one thoroughfare well known for its public houses; many have claimed to have drunk a pint in every inn along its way before reaching the cemetery gates. A trip from the Rosebud to the Hesketh Arms would have left few souls sober, after visits to the likes of the Carter's Arms, Queen Adelaide, General Codrington, New Hall Lane Tavern, Gibraltar Inn, Birley Arms, Belle Vue and Acregate. These days, on the site of the Princess Alexandra is a new building which is about to open as a Polish store, and a solicitor's now occupies the revamped Birley Arms building.

This paled into insignificance when a journey along the almost parallel Ribbleton Lane was undertaken. Beginning at the County Arms – which has recently been reduced to bricks and rubble – a stag party of seventy years ago could visit the Old Oak, Star Hotel, Anchors Weighed, Albert Hotel, Guild Inn, New Sun Inn, Birchall's Arms, Third Duke Of Lancaster, Fox & Grapes, Bold Venture, Derby Inn, Skeffington Arms and Old England all before last orders. The Fox & Grapes still survives, as does

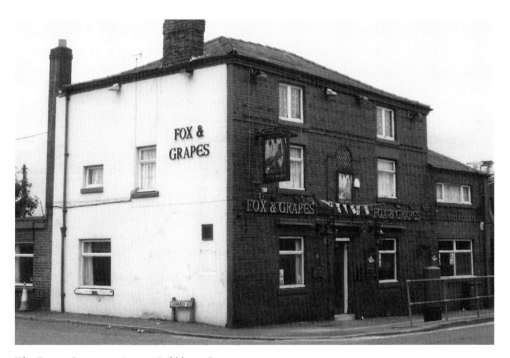

The Fox & Grapes survives on Ribbleton Lane.

the Skeffington, but the Derby Inn is now up for sale and, around the block, the Cemetery Hotel is now closed.

Many a regular has had a lump in their throat or wiped a tear from their eye after drinking the last pint in their beloved local. Such places might have had sawdust on the floor and spittoons; and the piano, or its player, may have been out of tune, but to the inn's regulars it was a place to cherish, a palace of pleasure.

The public houses still conjure up memories. The Anglers Inn, demolished in 1968 after serving the town since 1840, was a reminder of the heyday of Matthew Brown, with the figure of an angler above its entrance. The Boars Head bowed to the developers who coveted the prime Friargate site, closing its doors in the summer of 1983 and ending a 250-year term from the days of the landlady widow Walmsley, who was charged a poor tax of £6 back in 1732. The three-storey building had been a popular haunt for the Tetley Bitter drinkers of the town and, within months, televisions of DER had replaced tankards. Two years later it was the turn of its near neighbour the Waterloo Inn, named after the famous battle and opened in 1815, to put the shutters up after the developers moved in.

In 1962 it was last orders at the Kings Arms on the corner of Miller Arcade. Known by locals as the Long Bar on account of its 45ft-long bar, it was a popular drinking place for many Scotsmen; its most famous landlord was Hughie O'Donnell, the FA Cup-winning Preston North End player.

Frequenters of Lune Street will tell you of the Corporation Arms, which became a casualty of the ring road development in the late 1960s. Regulars would never tire of showing folk where musket balls had struck the exterior of the building during the riot of 1842.

There is now no trace of the Theatre Hotel on Fishergate, nor its former neighbour the ABC Cinema, with its 'Painted Wagon' basement bar. The last drinks were served at the Theatre Hotel one lunchtime in mid October 1987; when regulars returned that night for their usual Boddington's beverage, the doors were locked.

At the corner of Orchard Street and Market Street once stood the Farmer's Arms, a traditional calling place for farmers who hauled their produce overnight by horse-drawn wagons. The magnificent three-storey building was somewhat rundown by the late 1960s, and was taken over by the Chef & Brewer group, which turned it into the Jolly Farmer – a trendy place for young and old. Alas, by 1980 its prime position made it a target for the developers, who paid £400,000 to purchase it and turn it into shop units.

Down the ancient passageway known as New Cock Yard was the New Cock Inn, which was in fact the back portion of the old mansion of Thomas Winckley. It was famous for its beer and remnants of an old cockpit could be seen in an upper room, prior to the inn's demolition which made way for the Boots Chemist store fronting onto Fishergate.

In the summer of 1969, the town said farewell to the Port Admiral public house that stood on Lancaster Road, at its junction with Saul Street. The Ringway was about to sweep through and the first priority was to remove the landmark stone statues from the inn's roof. Napoleon and Nelson, together with a woman (naked except for a fig

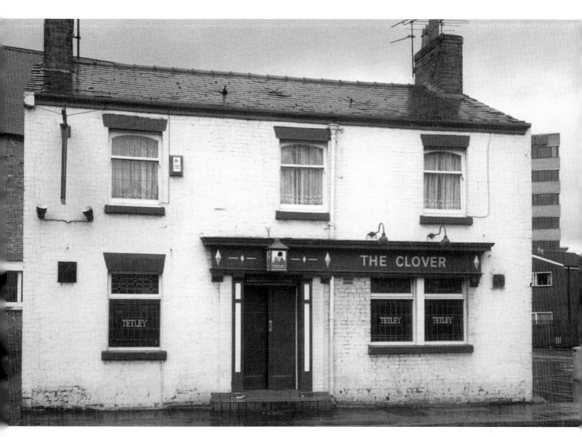

The Clover Inn on Meadow Street, c.1990. Now home to students.

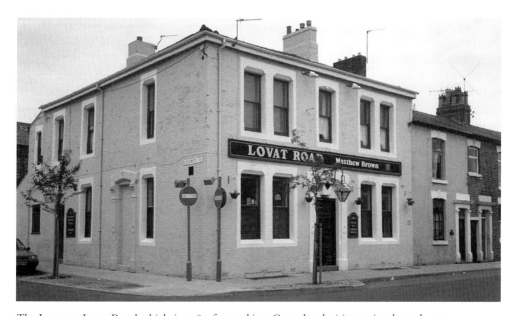

The Lovat on Lovat Road which, in 1989, featured in a Granada television series about the area.

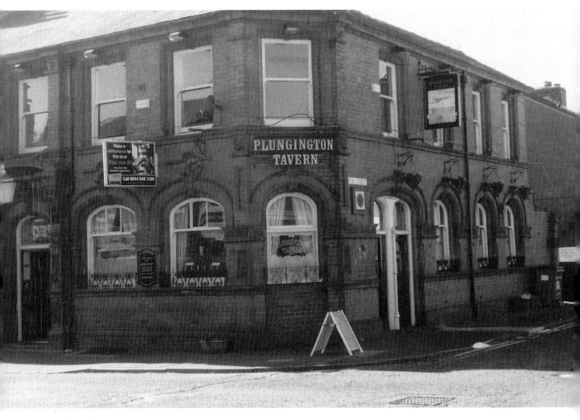

The Plungington Tavern.

leaf, and reputed to be Lady Emma Hamilton) were carefully removed, along with the four crouching lions that had looked out from each corner.

Along Meadow Street drinkers would regularly move between inns, but now the public houses are not so frequent. The old Meadow Arms, which spent its final years as Mister Pickwick's, is a derelict ruin and its neighbour, the Clover Inn, is now home to students. The Hyde Park Inn on St Paul's Road is no more and the nearby Windsor Castle, Red Rose Inn (formerly the Edinburgh Castle) and the old Stephenson's Arms (recently trading as Churchill's) have now put up the shutters.

The Watering Trough on Fylde Road and the neighbouring Princess Alexandra both advertise accommodation for students, as do the Maudland Inn on Peddar Street and the old Hornby Castle, while the old Doctor Syntax is a place for food. The UCLAN Student Guide of 1993 welcomed students for the new term with a pub guide listing 140 local inns or taverns – the list is shorter now, no doubt.

The drinks no longer flow at the North Star, nor at the Neptune on Strand Road, the Springfield on Bow Lane, the Lovat on Lovat Road, or on Aqueduct Street at the old Hermon Inn, Prince Consort or Lime Kiln. The Kings Arms, the Lamb Hotel of folk music fame and the George Hotel have all now called time, as indeed has the boarded-up Guild Tavern after days as Lionels Bar. Head to Plungington and the

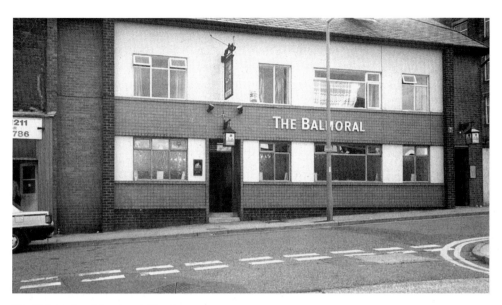

The Balmoral on Manchester Road, *c.* 1990.

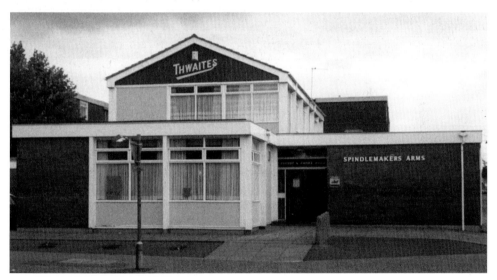

The short-lived Spindlemakers Arms, *c.* 1992.

Plungington Hotel, Plungington Tavern, Tanners Arms and Wellfield will still greet you, but the Royal Oak is now a Pizza Hut and the old General Havelock is a property shop.

The old Duke of Edinburgh on Deepdale Mill Street has long gone and the Boatman's on Marsh Lane no longer affords a welcome, nor is there a Brunswick on Charlotte Street, or a Spindlemakers Arms on Lancaster Road, and the old Balmoral building looks forlorn on Manchester Road. Back in 1989, along Avenham Lane you could quench your thirst at the Palatine, Frenchwood or the Avenham Park Inn – nowadays only the latter remains open.

The Cheethams Arms and old William IV have gone from London Road and the short-lived Falkland Heroes at Tanterton, named in honour of the conflict, became a burnt-out ruin; now the old Mitre Tavern on North Road is a place to take your pets. The list is long and no doubt stirs up memories by the barrel; if I have omitted your favourite I apologise.

Preston still has many flourishing public houses, with legions of regulars who rejoice that it is not 'Time gentlemen please' throughout the city. Perhaps, though, we should heed the warnings of Joseph Livesey, who looked forward to the day when the pumps ran dry for the good of mankind. Indeed, the coffee houses that are appearing on our streets would be much more to his liking.

9

READ ALL ABOUT IT

The newspaper industry has faced tough times during the recent recession, with many local newspapers, including the *Preston Citizen*, falling by the wayside. Thankfully, Preston still has its *Lancashire Evening Post*, continuing a long tradition of newsprint in the city.

The first newspaper appeared on Preston's streets as long ago as 1740. It was called the *Preston Journal* and only had a short existence, as did the paper that Robert Moon published five years later called the *True British Courant*. Headline-making news of the day would likely have been about the Jacobite Rebellion and the fleeting visits of Charles Edward Stuart, the Young Pretender. With a population of less than 6,000, the potential circulation was somewhat limited. One visitor to Preston back then was Daniel Defoe, the author of *Robinson Crusoe*, who wrote of his admiration for the mansions that flanked Fishergate and Churchgate. He also remarked on the lack of manufacture in the place, the number of learned gentry and the attorneys, proctors and notaries who wintered in the town.

A more serious attempt at establishing a regular newspaper took place in 1791, with the introduction of the *Preston Review*. In the half century that had passed, Richard Arkwright had patented his first spinning frame, John Horrocks had erected his first cotton mill, John Wesley had preached in Preston, stagecoaches had begun regular services between Preston and Liverpool, the parish church had been rebuilt, a workhouse had opened on Preston Moor, the House of Correction had opened and the Town Hall had fallen down.

Alas, that newspaper lasted barely twelve months and it was not until the nineteenth century that publishers managed to produce newspapers with any continuity. The *Journal* first appeared on the town's streets in 1807, eventually becoming the cornerstone of the *Preston Chronicle* with which it merged in 1812. Lawrence Dobson,

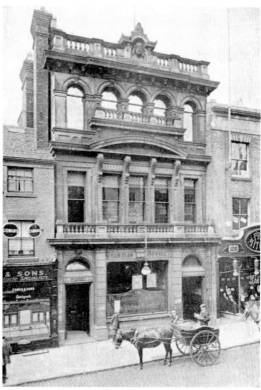

George Toulmin, Victorian newspaper pioneer.

The former LEP and *Preston Guardian* offices in Fishergate.

the man behind the *Preston Chronicle*, gained a rival in the newspaper stakes when Lawrence Clarke published the *Preston Sentinel* in 1821, which survived a year, and the *Preston Pilot* in 1825, which was to have much greater longevity. For brief periods the *Preston Observer* and the *Preston Advertiser* challenged the two main newspapers, but it was not until 1844 when Joseph Livesey, who had produced the *Temperance Advocate* publication, established the *Preston Guardian* that serious competition arrived.

In 1855 Stamp Duty on newspapers was abolished and the price of a daily read dropped considerably. Consequently, other newspapers arrived on the scene, including the *Preston Mercury*, *Preston Telegraph*, *The Wasp*, *The Echo* and the *Preston Herald*. With the population of the town rising to upwards of 55,000, they all attempted to establish daily publications, but without success.

In 1870, George Toulmin made a serious bid for the daily market with the introduction of the *Preston Evening News*, but this paper faltered after a few months. Undeterred, George Toulmin & Sons gave it another go in 1886 when they published for the first time the *Lancashire Evening Post*. By this time Toulmin had taken over the ownership of the thriving *Preston Guardian*, and the *Preston Pilot* had ceased publication. The new daily paper was designed to appeal to a far-reaching and diverse readership, and it was successful. The first edition appeared on Monday 18 October, consisting of

four pages and costing one half penny. The front page was devoted to advertising, with errand boys and domestic servants in demand, tea and cakes for sale and piano lessons on offer. The headline news inside included a fire at Hawkins Mill in Adelphi Street, a wife murder in Belgium and a report from the Lancaster Quarter Sessions.

The popularity of a daily newspaper caught on and the *Lancashire Evening Post* thrived, with a circulation far beyond the boundaries of Preston. In 1893 the paper changed its name to the *Lancashire Daily Post*, a title it took into the next century before eventually reverting back to its original name. In the following year the *Preston Chronicle* was published for the last time, leaving the *Preston Guardian* as the town's leading twice-weekly publication, with the *Preston Herald* (first published in 1855) remaining as a popular weekly rival from its print headquarters in Avenham Street until its final closure after a century of news reporting. Back in 1876, the newspaper made the headlines when Blackburn child-killer William Fish used back copies to wrap up the remains of his unfortunate victim. The gruesome find was made by Preston's famous bloodhound Morgan, which had been loaned to the Chief Constable of Blackburn to track the killer down.

The *Preston Guardian*, which in the nineteenth century was printed in Cannon Street and campaigned in its early days on such matters as Free Trade and the Anti Corn Laws, remained as popular as its sister paper the *Lancashire Evening Post* until the autumn of 1964, when it was merged with the *Farmers Guardian*. By this time the newspapers were all being printed at the *Lancashire Evening Post* headquarters in Fishergate, where town centre shoppers could purchase copies hot off the presses with latest racing results and football or cricket scores in the late news column. On a Saturday evening, shortly before six o'clock, a queue would form to obtain a copy of the *Last Football*, essential reading for the sports fans of Preston. These days, of course, the *Lancashire Evening Post* is printed at the newspaper's modern-day printing plant at Broughton, with a fleet of vans on hand to distribute the newspaper far and wide. After nearly 125 years of daily printing, that's over 38,000 editions and counting of the city's most popular paper.

10

ON THE BUSES

In 2009, news that Preston Bus was to be taken over by Stagecoach, after the rival bus companies spent a couple of years at loggerheads, was greeted with concern locally.

Preston has quite rightly been proud of its public transport network in the city, a tradition that began over 150 years ago when, in May 1859, an enterprising Richard Veevers of the town, with the backing of shareholders, introduced a service between Preston and Fulwood. This horse-drawn omnibus had a stuttering start and lasted

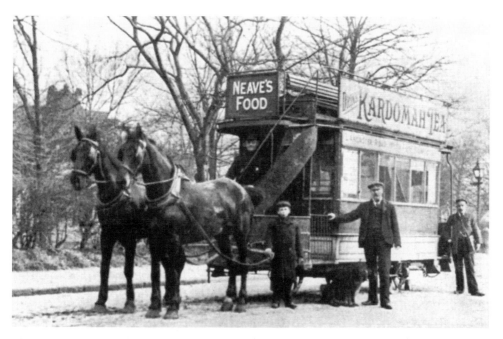

The horse-drawn tram at Fulwood in 1903.

barely a year. It did, however, lead to a more reliable service being introduced by a Mr Harding, who provided a more regular service on the original route and introduced another omnibus to take the townsfolk to and from Ashton-on-Ribble. The main problem he encountered was the tax on travelling, which demanded an extra duty if over five trips were made in one day.

After those humble beginnings, a tramway from Preston to Fulwood was introduced in 1879, extending from the top of Lancaster Road to the Prince Albert Hotel at Fulwood, where the Summers Hotel now stands. It was the Preston Tramway Co. who got the enterprise going, with the blessing of the Preston Corporation. This led to the introduction, three years later, of an enlarged tramway system by the Corporation, with a route through town from the bottom of Fishergate Hill to the Pleasure Gardens at Farringdon Park, near the cemetery, and another from the Town Hall to Ashton. The horse-drawn tramcars proved a great success, eventually running at intervals of ten to thirty minutes during the day.

By this time, the need for transport to country districts was also being catered for, with a daily omnibus to Higher Walton, a Saturday service to Goosnargh and a waggonette communication once a week to Walmer Bridge and Much Hoole.

In 1904, the Preston Corporation introduced its electric trams, running from the purpose-built depot in Deepdale Road. From their introduction in June that year, the trams became very popular and the Edwardians appreciated their new mode of transport. Indeed, fifty or more crammed onto that first electric tram – destination Fulwood Barracks. In the following years, the fleet of trams and the routes being serviced increased.

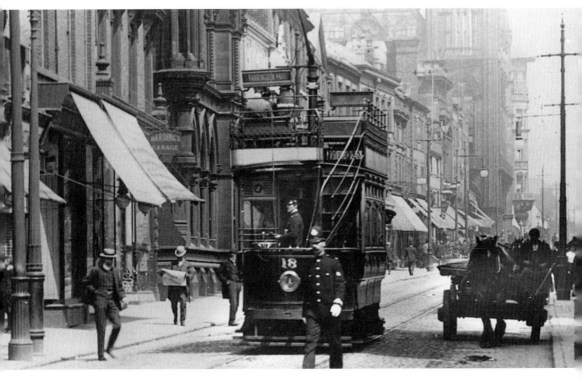

Electric tram number 18 on Fishergate in 1906.

A fleet of single, double or open-top trams could soon be seen on the streets of Preston, the main hindrance to progress often being the lengths of single track with passing loops, which caused problems at peak times. Of course, the new transport system created work for the English Electric Co. on Strand Road, a typical example being their supplying of three single-decker vehicles, in the autumn of 1912, to work the Ashton route at a cost of £2,500 each. Trams from the Dick Kerr's work were built for destinations around the world.

Unfortunately, as far as Preston was concerned the arrival of the motor buses led to the decline in tram usage after some thirty years, and the last electric tram to run in Preston made its final journey along the Fulwood route in December 1935.

By this time, various bus companies were using Starchhouse Square as a terminal. The open windswept square was used by the likes of Viking Motors (which operated a service to Great Eccleston, via Woodplumpton and Inskip, from 1920), De Luxe Motors, Bamber Bridge Motor Services, Majestic, Dallas, Brookhouse Motors and Scout Motors. Eventually, Preston had other bus terminals, in Fox Street – where Fishwick Motors had their base, the Ribble bus station in Tithebarn Street, and the Preston Corporation bus terminal that was generally around the Miller Arcade. A foretaste of our present situation followed when Ribble Motor Co. began to buy out the smaller bus companies, although the family firm of John Fishwick, that had begun in 1907, was able to resist any takeover bids.

Scout Motor Co., which began in 1919, became part of Ribble Motors in 1961, and in 1968, when Ribble became part of the National Bus Co., its name disappeared.

Despite the popularity of local bus services, it was always difficult to make a profit – although the Town Council of the time accepted their duty to provide local buses for local people. In 1954, the Preston Corporation reported that they had carried over 46 million passengers in twelve months, but had a balance sheet that left them £2,874 in the red. The best-patronised route that year was to Farringdon Park, with £35,000 taken in bus fares; the worst was to Pedders Lane, with only £339 taken from ticket sales. In those days, one-man buses with their exact fare policy were a long way off and the bus conductor, with his ticket machine, was very much part of the scene, overseeing his passengers' welfare – woe betide any youngster who was misbehaving. With the increasing number of motorists in the town, the bus services had to handle a reduction in passengers – although any proposed changes in services brought many a protest. The year 1963 saw many people object to the proposed axing of the Ashton B service that ran via Cromwell Road, and news that the bus fares were due to increase by a half penny caused quite a fuss.

It eventually became apparent that a new bus station was required to ease traffic congestion in the town. After a decade of great change, with the slum clearance programme in full swing, a new Preston bus station with multi-storey car park was opened in October 1969, on the site of the former Everton Gardens. It was described at the time, by the well-respected Lord Stokes of Leyland, as 'a model of imaginative planning, as good as anything in Britain and even in the world'. It seems that perceptions change, as four decades on there are plans afoot to remove it from the local landscape as part of the Tithebarn project.

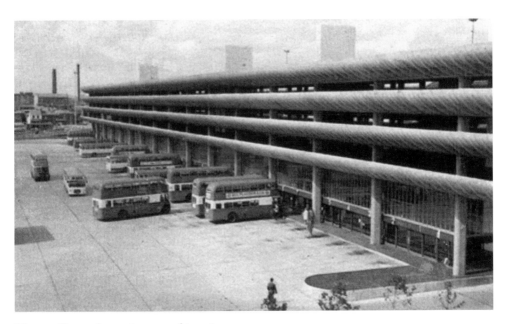

The new Preston bus station opened in 1969.

Present-day Farringdon Park bus.

One of the biggest threats to local bus services came in 1987 with the arrival of the mini buses known as the Zippy. They had a policy of picking up and dropping off customers at convenient points, and the brightly painted vehicles provided a nippy service. Before they were eventually bought out, they had the effect of making the local bus companies increase and improve services to prevent customers straying.

The Preston Corporation Bus Co. was eventually sold to its employees by the Town Council in 1993, with a large number of staff becoming shareholders. When the takeover was completed, Preston Bus was still operating out of the depot in Deepdale Road – once home to the trams – and had a fleet of over 120 vehicles. Amongst the Preston Bus Co.'s innovations was the introduction of the Orbital Service, which circles the town, increasing the bus links to many areas. For a company with origins in horse-drawn tram cars it had come a long way, and there is no doubt that the folk of yesteryear would be amazed to see the latest double-decker buses, which cost over £130,000 each and provide comfort and convenience for all. In November 2009, Stagecoach was ordered to sell Preston Bus by the Competitions Commission. as a consequence, Rotala, the West Midlands firm, struck a £3.2 million deal to buy Preston Bus.

WHAT A PICTURE: THE GOLDEN AGE OF THE SILVER SCREEN

These days, a trip to the pictures means a visit to either the multi-screen cinema down on Preston Docks or at Walton Le Dale. Both are extremely popular, and going to the movies is still a treat for young and old alike. In its heyday, though, Preston had no less than eighteen cinemas dotted around the town, providing a wide variety of choice for the locals.

The first animated photographs were shown around Lancashire as the twentieth century dawned, and they were usually part of a travelling fairground or touring circus that came to town. Although the early films were short, silent and in black and white, they attracted crowds wherever they were shown. In Preston, places such as the Public Hall were often rented for the touring film companies that began to emerge.

The first recognised cinema in the town was the old Temperance Hall, off North Road, which was opened by Hugh Rain – a pioneering figure in the development of the local film industry who, by 1908, had a full programme of films showing on a regular basis. In those days, the films were competing with the established theatres and music halls.

Within a decade Hugh Rain was busy converting the Temperance Hall into the Picture Palace, turning a former brewery in Brackenbury Place into the Picturedrome, and making the Princes Theatre, in Tithebarn Street, a cinema. If you add the Palladium, opened for Christmas in 1915, the Alexander Picture House in Walker Street, the Imperial at Mill Bank in Church Street, the Tivoli on Fleetwood Street, Bennett's Electric Theatre in Cragg's Row and the Marathon in Frank Street, the town was beginning to cash in on the popularity of the film industry.

The impressive new Empire Theatre on Church Street, which opened in May 1911, was equipped with a Bioscope from the outset, and within a few months a full week was dedicated to the showing of films. The reality was that cinema was becoming more popular than the stage and music hall, and silent movie stars such as Rudolph Valentino, Tom Mix, Clara Bow, Lillian Gish, Charlie Chaplin and the Keystone Cops soon became household names.

After the First World War, a number of enterprising individuals began to cash in on the boom with the opening of the Cosy Cinema (a converted chapel) in St Peter's Street, the Queens in Tunbridge Street, the Victory (another old chapel which was later known as the Rialto) in St Paul's Road, the Grand (later called the Regal and then the Lido) in Marsh Lane, the Savoy (a purpose-built cinema in Ashton Street), the Star in Fylde Road and the Guild in Geoffrey Street.

By the 1930s cinemas were becoming more comfortable, the wooden benches and dingy surroundings being replaced by comfortable seating in grand auditoriums; the

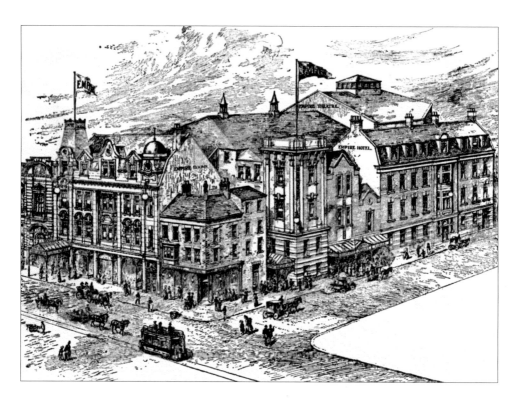

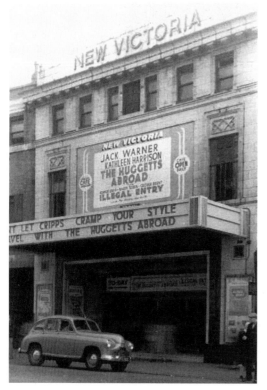

Above: The impressive Empire Theatre opened in 1911.

Left: The New Victoria cinema on Church Street, built in 1929. Later called the Gaumont and finally Odeon.

age of the talkies was well established. More cinemas were built in the suburbs to cater for their neighbourhood, including the Empress on Eldon Street, the Plaza (a converted cotton warehouse) on New Hall Lane, and the Carlton on Blackpool Road. The town centre was certainly not neglected either, with the New Victoria built in 1929 (later called the Odeon), the Theatre Royal and the Empire all showing films twice nightly. In 1937, the opening of the Ritz Cinema was greeted with delight; with a capacity of more than 1,500, it was filled to the rafters for the first film starring local favourite George Formby.

At the start of the Second World War the cinemas closed for a brief period; their reopening led to a great boom in audience figures, although on occasions the programme was interrupted as air-raid warnings were flashed on to the screens.

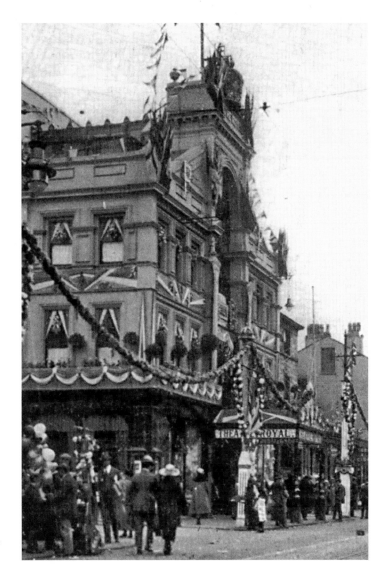

The Fishergate Theatre Royal decorated for the Preston Guild of 1922.

The two-screen Odeon was the last cinema to close in the town centre.

The daily entertainment listings of the *Lancashire Evening Post* for Christmas 1941 confirmed that it was business as usual. Besides the two pantomimes on the stages of the Royal Hippodrome and the Palace Theatre, there were films showing at the Ritz, Palladium, New Victoria, Empire, Empress, Theatre Royal, Star, Cosy, Savoy, Guild, Plaza, Carlton, Princes Theatre, Picturedrome and Rialto throughout the festive season. Dorothy Lamour starred in *Moon Over Burma*, Errol Flynn in *Footsteps In The Dark*, Bing Crosby in *Star Maker* and *Road to Zanzibar* and Mickey Rooney in *Men of Boys Town* – to name but a few of the stars of the silver screen.

However, the coming of the age of television led to an inevitable decline in audience figures, the first to suffer being the neighbourhood cinemas that closed one by one from the late 1950s onwards. Brave attempts were made to stay afloat – both the Lido and the Queens went into the continental X-rated film business before closing in the early 1960s. The Carlton Cinema, the Empire and the Ritz all went in for 'eyes down and a full house' as bingo halls began to flourish and the Palladium, bought by the Corporation in 1968, was demolished for a service road.

Somewhat against the trend, the ABC Cinema was built on the site of the old Theatre Royal in 1959. This Fishergate cinema was opened to a great fanfare, with film actor Richard Todd present and the film *Reluctant Debutante*, starring Rex Harrison, being shown.

Not to be outdone, the Rank Organisation invested over £250,000 in giving the Gaumont a makeover, and they unveiled the Odeon Cinema in May 1962. Occasional blockbusters would lead to a clamour for cinema places but the general decline continued.

Eight years after its re-opening, the Odeon was made into a twin-screen cinema and, in 1973, the ABC reduced its capacity and created the Painted Wagon saloon bar in a bid to boost trade. Alas, a decade later the cinema screened its last film and the site

awaited redevelopment for a number of years – such a short life for a state-of-the-art cinema. Somehow the Odeon managed to carry on for a while longer, but the emergence of the multi-screen cinemas eventually sounded its death knell. The city centre cinema is no more but, despite the age of the video and DVD, the industry still flourishes with all its traditional trappings of popcorn, ice cream and soda in warm, comfortable auditoriums with surround sound.

12

OUR GREEN AND PLEASANT LANDS

Local folk will be forever grateful for the efforts made from the middle of the nineteenth century which ensured that Preston had its share of green and pleasant land.

The roots of Preston's parks belong very much to the period when America was gripped by civil war and supplies of raw cotton from the southern states dried up. The cotton famine set in towards the end of 1861 and continued until the middle of 1865.

The cotton trade of Lancashire was paralysed as a black cloud hovered over the county's cotton workers. The great chimneys ceased to smoke, the whirling machinery was brought to a standstill and the spindles and looms were as hushed as if it was eternal night. As a result, poverty reigned supreme amongst the operatives and, by the winter of 1862, the full effect was apparent to any visitors to Preston. In the town, as elsewhere in Lancashire, a Relief Committee was set up and the Poor Law Guardians had to relieve many thousands of folk who were on the brink of starvation.

The Guardians attempted to resolve the situation by employing the able-bodied in such tasks as stone breaking and earth excavation in return for a shilling per day and a small bag of meal to feed their distraught families. There were times when the workers revolted and angry mobs challenged the authorities, whose task to ensure bread and soup for all was a formidable one.

With the mills closed, the Corporation resolved to provide meaningful employment and set the workers to developing the land on Preston Moor and Avenham. During the period 1843 to 1852, the Corporation purchased the whole of the proprietary rights to the twenty-six acres of land that would form Avenham Park. They then worked to transform its field-like form into beautiful grassy slopes; this moved on apace with the introduction of relief workers. Walks were created, trees and bushes were planted, and the avenue of lime trees was created by the side of the river. The park was developed under the guidance of the popular London landscape gardener Henry Milner, whom the Corporation had recruited.

On the northern side of town, workers were recruited to further develop the land known as Preston Moor, which was originally common land, being part of the forest of Fulwood. Back in 1834, the Corporation had enclosed some 100 acres of this rough,

uncultivated, heathery expanse of moorland. Once again, plans drawn up by Henry Milner were used as draining, levelling, road making, and flower and shrub planting progressed quickly, thanks to the efforts of the Poor Law recruits. The outcome was an open space with a colonnade of lime trees, as well as ornamental gardens and shrubbery, with a Serpentine Lake and playing fields to follow in due course.

With the parks developing significantly, Alderman Thomas Miller made the next noteworthy contribution when, in 1864, he gave the town 11 acres of land adjoining Avenham that would become Miller Park. The gift was bestowed on the condition that each year the Corporation would pay £40 to Preston Grammar School to assist students striving for a university education. Its development, also planned by Milner, included the principal terraced walks and a central stone stairway to the ornamental pond and fountain.

As the traumatic time endured due to the cotton famine drew to a close, Preston had a rich legacy that future generations could enjoy. It was calculated that the forming of Avenham and Miller Parks cost a little over £20,000, and that another £10,000 had been spent on developing Moor Park. With an annual upkeep bill of £2,000, the Corporation were pleased with the outcome and the fact that the years of hardship had provided something tangible in return.

On the outskirts of the city, just past the Preston Cemetery, the Preston Pleasure Gardens opened in 1877, covering some 43 acres of land. Miles of walks were laid out and the picturesque setting was made accessible to the public. Entertainment and horticultural shows were arranged in the grounds, but a couple of years of wet weather

Serpentine Lake on Moor Park, an idyllic setting in 1902.

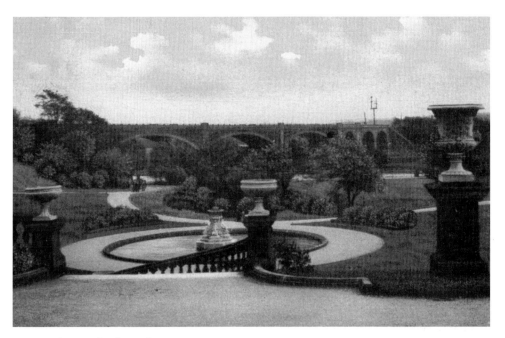

A postcard view of Miller Park, 1905.

led to the company behind the project going into liquidation. After the First World War, part of the site was used as a motorcycle speedway arena, attracting large crowds, but this ceased in the 1930s after some tragic accidents. The area commonly known as the Dingle was eventually neglected, until 100 years later when a Preston Corporation initiative led to it being restored, with footpaths and the new name of Vauxhall Park at Farringdon.

The next significant contribution to Preston's pleasant parks occurred in 1910, when Haslam Park was opened. This land was donated by Mary Haslam in memory of her late father, the cotton manufacturer John Haslam. With an avenue half a mile long, lined by lime saplings, and with Spanish and sweet chestnut trees as well as Norwegian maples within its enclosures, it soon became a popular haunt. The large model yachting lake, fed from the nearby canal by a natural waterfall, added to its attraction.

The year 1915 saw the opening of Waverley Park, located close to Preston Cemetery and known officially these days as Ribbleton Park. With tree-lined footpaths and playing fields, it was a welcome addition to the neighbourhood.

In 1938, just before the Second World War, the Corporation bought from the English Electric Co. a plot of land that would become Ashton Park. This former sports field, with the enclosed mansion that was once the home of banker Edward Pedder, was soon developed into another pleasant parkland. With tree-lined avenues, ornamental gardens and playing fields, it soon became popular with local folk.

After the Second World War, the Preston Corporation bought the land in the centre of Winckley Square that had become a tangled overgrowth during the war years. The origins of this land go back to the eighteenth century, when it was known as the Town

The bandstand in Avenham Park. This was constructed in 1903 and had a life of fifty years.

End Field. It belonged to Thomas Winckley, a local attorney, who sold off plots to the wealthy for the erection of large Georgian houses. The houses had no gardens, but the square was divided so that each house had a plot of land in front. After purchase, the Corporation landscaped the gardens for the benefit of the public and they remain a tranquil refuge just off the city's main thoroughfares.

Towards the end of the twentieth century, work was undertaken to restore Grange Park, originally opened in 1955, to its former glory. This park has its roots in the nineteenth century, being created on the land where Ribbleton Hall once stood. As part of the refurbishment, the ruins of the old Ribbleton Hall (built in 1865 as the family home of solicitor and former Mayor of Preston Thomas Birchall) were excavated. The foundations of the hall were used as a feature of the restored landscape, with woodland walks and a kitchen garden to delight visitors.

Currently, the Parks Department are concentrating their efforts on an upgrade of both Avenham and Miller Parks. In Avenham Park, the old bandstand down the valley has gone and a new pavilion has emerged with a café. New paths have been laid in both parks and the Victorian fountain, with figures depicting Earth, Air, Fire and Water, in Miller Park is once more in full flow – but the old familiar avenue of ancient trees by the riverside has fallen victim to the passage of time.

There is no doubt that Preston has its share of green and pleasant lands, with parks being supplemented by recreation grounds, playing fields and allotment sites dotted around its boundaries. It is a legacy left by Preston's famished poor and continued by later generations for all to enjoy.

FIRST CLASS: THE POST

Our postal workers deliver day after day, but it is at Christmas time that they really come into public awareness. Each year the postal workers of Lancashire prepare themselves for the rush of Christmas greetings in the run-up to the festive season. Year after year record numbers of Christmas cards and parcels are dealt with; Preston is no exception.

The main Preston post office is no longer housed in the magnificent building that fronts onto the Market Square and served the town for a century. Nonetheless, it remains just as busy at its new location on Theatre Street in the annual stampede to send good wishes far and wide. When the old post office building was first used, in 1903, mail was actually delivered on Christmas morning, and a proud postmaster reported that over 90,000 cards and letters had been despatched that day.

In the early days, postmasters had responsibility for the upkeep of the road services and the prompt arrival, safety and forwarding of the mailbags. They were not concerned with the actual deliveries to individuals. As the eighteenth century drew to a close, the services in Preston had developed into a local office for delivery and reception of letters. At this time, Thomas Cooper was the deputy postmaster responsible for the Preston mail, followed in 1805 by his daughter Rachel Hardman, who remained postmistress in Preston for close on forty-five years.

The earliest recorded building for the reception of letters was near the southern end of Lancaster Road in the Shambles area, and was part of a butcher's premises. A move followed in the early nineteenth century to a building in Church Street, close to the old Grapes Hotel and Derby Street. Customers were obliged to do their business from the footpath, communicating with the postal official through a small window. It was a costly business to communicate by letter at this time, so the mailbags were rarely bulging.

In 1817 the postmistress also took over responsibility for a foot post between Preston and Blackburn and the town got its first official letter carrier, John Johnson. It was payment on delivery, and the carrier paid the postmistress for letters before commencing on his round. He had to collect his fees from those receiving the letters and, if they lived outside the borough boundaries, a surcharge of an extra penny was made.

Great changes were made in the postal system in the middle of the nineteenth century; notably, adhesive stamps (the brainchild of Rowland Hill) and the arrival in 1840 of the penny post for inland letters. Advantage was taken of the developing rail network to shift the post, instead of using the old mail coaches.

Up until this time the Preston postal business had been very much a family affair, with Mrs Hardman being replaced by one of her two spinster sister assistants when she died and John Johnson enlisting the help of his two sons, Josiah and Mark, as his workload increased. One of Josiah's proudest recollections in later life was the day in 1837 when he successfully delivered a letter from Ireland that had been simply

Left: The iconic Victorian post box remains on Market Street.

Below: The post office viewed from Mount Street today.

addressed 'No. 5, Preston'. A gang of Irish labourers were busy constructing the North Union Railway at the time, and he approached them to ask if anyone was called by the name on the letter. 'Sure, that's me,' said one of the gang and, upon opening the letter, he discovered that the priest back home had written to tell him that his wife had given birth. Josiah was known for keeping people waiting for their correspondence while he chatted playfully to the servant maids who answered the door.

In January 1852, the old system in Preston was swept away when William Drennan arrived from the Liverpool GPO and was appointed postmaster of Preston, soon operating from a three-storey building in Lancaster Road. Over the next thirty years he had to cope with a weekly letter delivery service that had increased five-fold to over 130,000.

A move to new premises on the north side of Fishergate, next to the Preston Gas Co., took place in 1870 and around ten years later the post office staff numbered ninety-two, with eighteen letter carriers employed, and twenty pillar boxes and seven branch post offices within the old borough boundaries.

In the twentieth century the Post Office continued to grow, with sorting offices in Fleet Street and Corporation Street, and district engineering works in the old grammar school building. For a decade between the wars, the postmaster of Preston, Robert Taylor Vity – who was an expert in telephone and telegram systems – lectured on the subject to students at many universities. George Sunley, who in 1933 had responsibility for a staff of over 700 dealing with half a million letters and parcels each week, followed him in the role. During Christmas week that year, over 1.5 million cards and letters

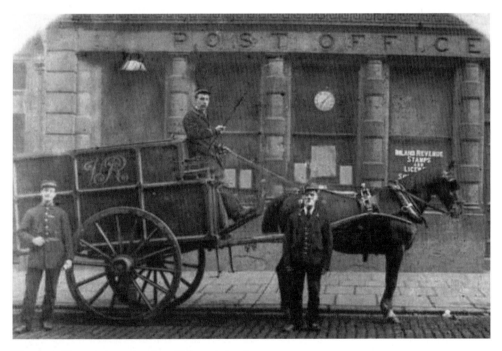

The post office was operating from Fishergate in 1870.

were delivered and, on a warm and sunny Christmas Day, the postmen cleared the last of the deliveries, finishing in time for a well-earned dinner.

By Christmas 1945, the public had heeded the Post Office's plea to post early and, although the volume of mail was equal to the past, the peak of delivering occurred six days before Christmas. By Christmas Day the temporary staff had been dismissed and only the regular postmen went out in the pouring rain to pass the final Christmas greetings to the folk of Preston.

By 1961 the Christmas Day deliveries had ceased, but the Post Office was a hub of activity when the Mayor of Preston made his customary tour days before Christmas. Fred Irvine was greeted by 150 telephonists at the GPO main building, by many parcel handlers at the railway station, and witnessed hundreds of staff sorting out the Christmas mail at the Hartington Road and Fleet Street offices.

In 1963, postman Cyril Evan Molyneux became Mayor of Preston; fittingly, one of his duties in October that year was to officially open the new GPO sorting office in West Cliff. Costing over £500,000, the building was the very latest in sorting office mechanisation and put the town's postal system up with the best in the land. It was hard to imagine then that a few decades on the operation would be run from its present location on Pittman Way in Fulwood.

Of course, we will be advised to post early once more next Christmas, and rest assured the postman won't be calling on Christmas morn to deliver late cards but will be at home enjoying a well-earned rest after another hectic festive season. Mind you, these days you can send your own Christmas message on the day by text or email – something that would have seemed like magic to John Johnson.

14

REMEMBER, REMEMBER THE FIFTH OF NOVEMBER

The fifth of November is a significant date in the British calendar, filled with firework displays, bonfires and burning effigies of Guy Fawkes. It all marks, of course, the anniversary of the 1605 Gunpowder Plot, when plans were afoot to blow up the Houses of Parliament and the ruling monarch, King James I. That both Parliament and King survived was enough to give way to an annual celebration and, as the population of the towns increased, traditions developed that we continue to this day.

The fire brigades of the country are always glad to see the back of Bonfire Night, and the Preston firefighters are no exception. Prior to 1724, when the local MP presented a fire engine to the town, there was no machinery for extinguishing fires, and only in the early nineteenth century was it thought necessary to enlist a more capable body

of men and equipment. The old lock-up in Avenham Street was converted into the headquarters of the Preston Fire Brigade and they operated from there, being the proud possessors of three manual fire engines with the grand names of *Victoria*, *Prince of Wales* and *Waterwitch*.

Back then, the only means of rallying the firemen to attend a fire was by ringing a bell that was kept in the police station yard. The engines were then dragged from their place and pushed to the scene of the fire. Horses were very rarely used, and the policy was that if the fire was out of town, then the first horse met with on the street was commandeered, un-harnessed and attached to the engine. Often the nearest pump was some distance from the blaze, and firemen and volunteers would make a chain, passing the leather bucket filled with water from hand to hand.

Things improved by the middle of the nineteenth century with the erection of the purpose-built fire station in Tithebarn Street. With the cotton industry thriving, there were many calls on the fire brigade (run by Henry Marriott from 1854), such as the destructive fire at the Greenbank Mill of Messrs John Hawkins in February 1861.

Back in March 1860 a fire was raging in the Market Place at the premises of Mr T.B. Dicks, the grocer and tea dealer. That night, flames engulfed the three-storey building, and two children perished before firemen could quell the flames.

It was a similar story in March 1875, when a fire broke out on the premises of tailor James McNeil in Church Street. That night, three grown-up sons of the tailor perished, overcome by smoke in the upper storeys of the building, despite the heroic efforts of the firemen. At that time, members of the fire brigade were volunteers who

Tithebarn Street fire station opened in 1852 and closed in 1962.

practised once a month, for which they received 4s, and on attending a fire were paid half a crown for the first hour and a couple of shillings for subsequent hours.

When Mr Marriott died in 1883, the duties of the fire brigade superintendent were taken over by Mr Alonzo Savage, who developed things still further and, by the turn of the century, the premises had been improved. There were steam fire engines, and four horses were stabled in purpose-built quarters at the rear of the station. The firemen were also close at hand, living in houses in nearby Everton Gardens and on round-the-clock alert.

Mr Savage was highly dedicated and gave fifty years' service to the fire brigade; when he retired in 1909 his son, also named Alonzo, followed him as the chief fire officer. Two of his sons were also recruited to the firefighting business, which was controlled by the Savage family until Alonzo retired in the summer of 1931, after almost fifty years' service. Alonzo Savage junior was a familiar figure to the townsfolk; he possessed a silver helmet that had been presented to him for his heroics in 1917, at a blaze at the explosives factory in Lancaster.

The professional way the service was developing was shown at the Preston Guild of 1922, when the fire brigade paraded proudly with their motorised Merryweather fire engine. Visitors to the station were also treated to the sight of a long row of tunics, belts, axes and helmets ready for action.

As the fire brigade developed, so did November the Fifth parties; it became traditional for bonfires to be lit on the cobbles amongst the terraced streets with chestnuts roasting, piping hot parched peas, and trays of treacle toffee devoured by the mouthful, after weeks of gathering wood for the fire. The final act of the night was the

The engine and crew outside Tithebarn Street fire station, 1896.

Left: Oliver Budd, Fire Chief 1958–1971.

Below: Engines on display at the opening of Blackpool Road fire station in 1962.

burning of the guy, which had spent the last few days in shop doorways, as children pleaded for a penny to get some money for fireworks.

When Oliver Budd arrived in the town in 1945 to join the fire brigade – which he would run from 1958 until his retirement in 1971 – he was amazed when the brigade received almost 200 calls on his first Bonfire Night in Preston, with fires on almost every street corner. Throughout the years he attended many blazes, including one at Margerison's Soap Factory on 5 November 1948; the devastating fire that gutted the Town Hall in March 1947; two gigantic blazes at Pykes Corn Mill in 1955 and 1956; the blaze at Parkinson's Biscuit Factory in 1955; the arson that destroyed Goobys, the ladies' fashion store, in Church Street in March 1965; and the blaze that ruined the Castle Vernon Bowling Alley later the same year.

In April 1962, Oliver Budd was responsible for overseeing the move from the 110-year-old Tithebarn Street station to the new fire station on Blackpool Road, officially opened by the Mayor of Preston Council, Fred Irvine, in May. Among the fire engines moved to the new premises was the brand new 'Merryweather', equipped with its 100ft turntable ladder. The move to the new £154,000 premises went smoothly, the brigade being called out within minutes of their arrival. For all his firefighting, Oliver Budd was most proud of having reduced the number of call-outs on Bonfire Night to a handful.

15

BANKING ON PRESTON

When one moves around our city, it is apparent that a number of our banks are housed in the finest of buildings – although some, like the former TSB Bank on Church Street, are in need of attention now. Should you make your way along Fishergate, you will find a number of impressive buildings, many of which are banks or building societies – there are almost as many places along this shopping thoroughfare to save your money as to spend it.

For centuries, Preston folk have been encouraged to save their money. The site where the old TSB Bank now stands was used for banking purposes in 1776, when Messrs Atherton, Greave & Co. opened for business in what was an old Jacobean mansion built in 1690. Subsequently, a succession of banks operated from the TSB site until 1862, when a branch of the Manchester & County Bank opened there. Eventually, that particular bank outgrew what had become affectionately known as the Old Bank, and moved to the bottom end of Fishergate, leaving the premises to be converted into shops for a period.

Having commenced in 1816 within the National School on Avenham Lane, and operating from a Fishergate location (the old Dispensary buildings opposite

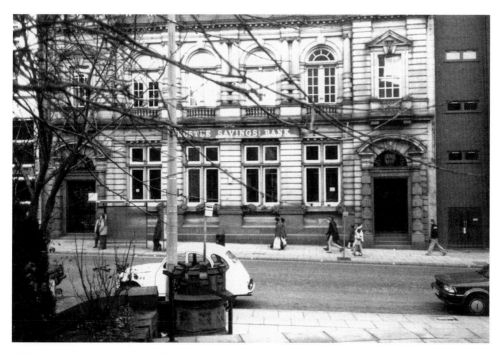

TSB on the Preston Savings Bank site in 1990s. The TSB have now ceased trading here.

Customers queue for service at Preston Savings Bank on Church Street. This grand building opened on the site of the Old Bank in 1906 at a cost of £25,000.

Chapel Street) since 1871, the Preston Savings Bank eventually announced grand plans for the former Old Bank site. Work on the new bank commenced in 1905, to the design of Preston architect Mr W.H. Thwaites, in a English Renaissance style, with £20,000 earmarked for its erection and another £5,000 allocated for its internal furnishings. With two entrances facing Church Street, polished Shap granite used for the base and doorways, and a front of polished Longridge stone, it was intended to be pleasing to the observer.

An article entitled 'Thrift', written in 1875, remarked this of Preston Savings Bank:

> The inhabitants of Preston have exhibited a strong desire to save their earnings during the last few years, more especially since the last great cotton strike. There is no town in England, excepting perhaps Huddersfield, where the people have proved themselves so provident and thrifty. By last year one in five of the population of Preston deposited money in the Savings Bank. In all £472,000 had been accumulated by 14,792 depositors.

Besides the Old Bank, nineteenth-century Preston folk had the Lancaster Bank in Fishergate, adjoining Butler's Court (opened originally in 1828), the Preston Bank (opened in 1856), and the Preston Union Bank in Lune Street (opened in 1883).

It is fair to say that not all of those early banks prospered. Back in 1861, at the time of the cotton famine, there was great panic in local banking circles following the sudden death of Alderman Edward Peddar, a member of a well-established local banking family. His grandfather had been involved in the opening of the Old Bank in 1776, and down the years the name of Peddar was in the various titles that the bank adopted.

Edward Pedder. His sudden death led to panic in banking circles.

Edward Peddar's death, at the age of fifty-one, at his mansion (now surrounded by Ashton Park), led to unease in financial circles and, by the following day, a notice was displayed on the closed doors that the business would be wound up. The Peddar family tried to avert the crisis but without success, and eventually an aggregate of 17s 6d was paid for every pound deposited. It was a sad ending for a bank that, back in 1792, had been one of only fifty which had overcome a monetary crisis during which 300 of the nation's banks stopped payment. Consequently, the saying in Preston and district then was, 'As safe as Peddar's'.

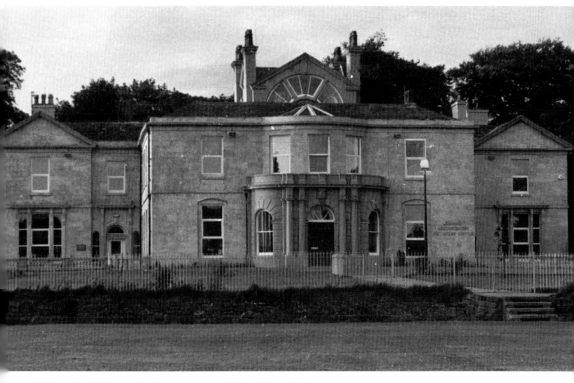

Edward Pedder's mansion is now surrounded by Ashton Park.

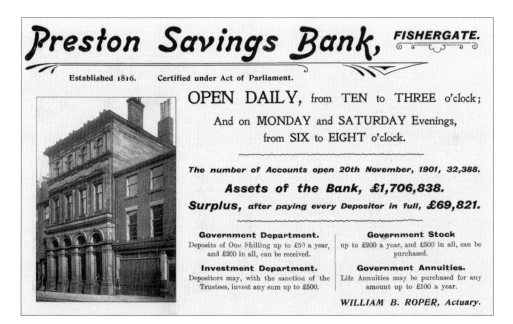

An advertisement for Preston Savings Bank from 1902.

One of Preston's finest bank buildings is the former Preston Bank on Fishergate; now empty, it was once the HSB Bank and formerly the Midland Bank. This impressive and elaborately fronted building was opened in 1856, and amongst the bank's early employees was a junior clerk called Gerald Thomas Tully, who would eventually earn notoriety throughout the town. Tully had worked his way up to sub-manager by 1866 and, when his chief retired in 1883, he had hopes of replacing him. Alas, another man was given the post and Tully seemed to accept the situation. However, with the change of manager came the usual searching audit, and when the auditors moved in, Tully slipped out and headed for the railway station. The reason for Tully's swift departure was soon evident, as defalcations were discovered – he had helped himself to £10,000 (over £300,000 by today's values). All that his wife received was a letter bearing a Manchester postmark, saying he was away on business for a few days. A warrant was at once issued for his arrest, but nothing was heard of him until the spring of 1884. At that time, Preston magistrate Joseph Toulmin, a member of the LEP founder's family, was in New York with his wife when he spotted Tully on Broadway. When approached, Tully claimed his name was Richardson, but Mr Toulmin followed him until he saw a police officer and Tully was taken into custody. Transatlantic communications followed but, despite being held for three months, a legal loophole prevented his extradition and he eventually moved to Chicago. Tully was informed that his wife and son had gone to live in Manchester in distressing circumstances. The next news of the infamous bank swindler came in April 1888, when it was revealed that he had died in Chicago.

It seems that Preston has a rich banking history and interest in our banking buildings remains high; it is pleasing that the impressive structures remain as landmarks in our city.

16

Preston Bobbies On Parade

With the coming of Community Support Officers – dubbed 'Blunkett's Bobbies' in 2004 – modern policing underwent significant change. The newly uniformed officers soon became familiar on the Preston scene. Preston is currently policed by the Lancashire County Constabulary, yet until 1969 the Preston Borough police force patrolled the town's streets.

Back in 1815, some thirteen years before London got its Metropolitan Police, the local police force was established under a Corporation Act. It seems that we were ahead of even Sir Robert Peel's forward thinking. There is no doubting his contribution to the forces of law and order, and we even have a statue in Winckley Square to remind us of his achievements. It was Sir Robert Peel who introduced far-reaching legislation which led to the passing of the Municipal Corporation Act in 1835, which gave 170 boroughs their own police forces controlled by a local Watch Committee.

Towards the end of the eighteenth century, the civil guardianship of Preston was entrusted to watchmen, who were often sponsored by private individuals or corporate grants. By 1810, the town had three official constables who were each paid £1 a week and they, along with the watchmen, guarded the streets. Within five years, the Corporation had created a recognised police force, with matters being run by Thomas Walton, the first Chief Constable of Preston; a police station was opened in Turk's Head Yard off Church Street. Thomas Walton earned upwards of £250 a year, and was paid partly on the results achieved by himself and his six constables. For each warrant executed he got 3s, and every summons issued earned him 1s. If he apprehended a deserter within the old borough boundaries, he was 20s better off.

By 1832, the need for a new police station was solved by opening premises in Avenham Street. That year John Addison, the new Mayor of the town, presented the force with their first official uniform, which they wore only on Sundays as they didn't want to spoil it. The uniform that became standard issue for nineteenth-century constables was a suit of blue cloth with a frock coat, on which was displayed the officer's number. A chimney pot hat bearing the letter 'P' was the standard headgear. For winter,

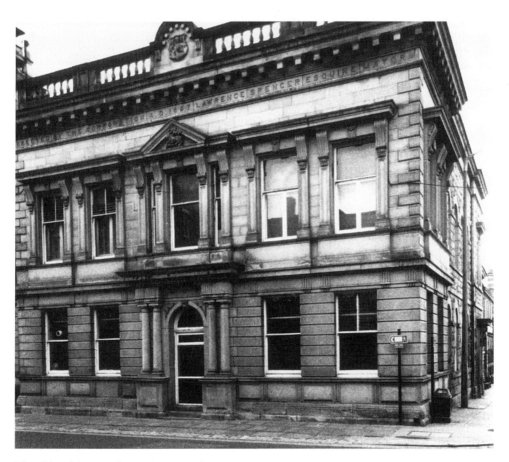

The old Earl Street police station opened in May 1858.

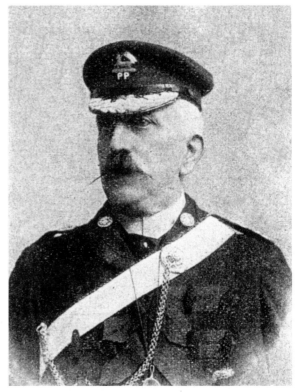

Major Francis Little, Chief Constable between 1882 and 1908.

a heavy dark-brown overcoat was provided.

In 1836, a year after the Municipal Corporation Act, Thomas Walton retired and Samuel Banister became Chief Constable; he was in charge for seventeen years before retiring on a pension of £100 per year. Next came Joseph Gibbon, who retired in 1863 after a decade of service, during which time the force became forty-strong. His early days in charge were eventful due to the lockout of the cotton workers that began during the winter of 1853.

He was followed by James Dunn, who had arrived from Swansea where he had held a similar position; during his time, the force was increased to eighty-eight and included the first plain-clothes detectives. A typical year for James Dunn was 1866, when he reported to the Watch Committee that one murder, three attempted murders, three shootings, one rape and one case of bigamy had kept his officers busy in the old borough during the twelve months. Another of the policeman's duties was to attend to stray dogs, and over 250 had been destroyed that year.

All of the early chief constables had their problems with rioters, either at General Election times or due to industrial strife. One of the most legendary feats by a nineteenth-century policeman – PC Sam Norris, a constable of twenty years' standing – was the single-handed arrest of twenty-six rioters during the Lune Street Riot of 1842.

In May 1858 the new police station was opened in Earl Street, and, during the winter of 1862, the new headquarters had to be guarded by the military as crowds gathered on the Orchard during the cotton famine troubles.

In 1872 Joseph Oglethorpe, who had risen through the ranks, became Chief Constable – a position he held until Guild Year 1882 when he was succeeded by a military man, Major Francis Little. The new Chief Constable had a force of almost 100 men; the station cost close to £9,000 per year to run. His reward for the long hours he spent supervising a borough where crime was at worrying levels was an annual salary of £350; a constable at the time earned £68 per annum.

In fact, Major Little brought the crime figures down and guided Preston Borough police force into the twentieth century. In 1903, the first Motor Car Act was

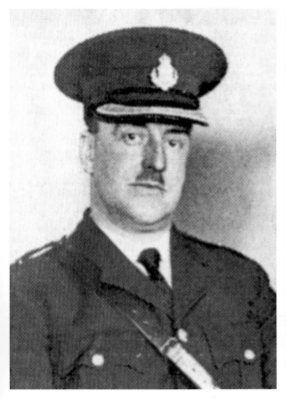

Henry Garth was Chief Constable for almost twenty years.

Lawson Street police station – recently abandoned in a move to Lancaster Road.

introduced and the initial maximum speed limit was set at 10 miles per hour. Major Little remained in control until 1908 when he retired, aged sixy-seven.

The Chief Constable who followed was Lionel D.L. Everett, who sought to improve the morale of his officers. One of his first initiatives was to introduce an official refreshment break during ten-hour shifts, and an allowance for plain-clothes officers to buy a waterproof raincoat was also well received. After four years, Mr Everett was off to Liverpool to become Assistant Chief Constable there.

The next Chief Constable of Preston was Captain John Unett, who had control during the early years of the First World War. James P. Ker Watson succeeded him. During his twenty-two-year spell at the helm much progress was made, with the introduction of the electric traffic lights, and police cars fitted with wireless transmitters.

By the Second World War the Chief Constable was Henry Garth, who spent almost twenty years in the demanding role, taking the force into the 'Dixon of Dock Green' era of policing. A Preston-born man, he had joined the force in 1911 and during the Second World War he was awarded an OBE, in recognition of his additional work for the war effort.

When he retired in 1956, he was replaced by Frank Richardson who, as it transpired, was the last Chief Constable of Preston. He had spent his early years with the

Nottingham City police, where he soon rose through the ranks. Within two years of his appointment, the Preston force was 216 strong – including thirteen women. Traffic on the roads had doubled since the war years and road safety took up an increasing amount of his time. Fourteen fatalities on the roads in 1958 emphasised the need to improve road safety. That same year, seventy-five children had been reported lost within the old borough boundaries; thankfully, all had been found and restored to parents or guardians.

Frank Richardson was at the helm in April 1969 when the merger with Lancashire County Constabulary took place. Sadly, his time with the county force was short, as he died suddenly in August 1969, whilst on a fortnight's break from his duties.

The merger meant that the Chief Constable of Lancashire, William Palfrey, was in charge of policing in Preston. In 1965 he had been heavily involved in the increase in mobile policing – with the introduction of small blue cars with white doors and stripes that earned the nickname the 'Pandas' – in the hope that mobile policing would reduce crime. It was the birth of the 'Z Car' era of policing, and Palfrey became a well-known figure all over Lancashire.

Recently the Preston police station has been relocated from its familiar home in Lawson Street and is operating from new premises on Lancaster Road; the HQ for the Lancashire force is at Hutton, from where the Chief Constable of Lancashire controls our city.

Glancing through the 'Letters' section of the local nineteenth-century newspapers, it seems that many of the problems the Preston police have to face are not dissimilar to those tackled by the old constables. It appears that youths were dancing and shouting on street corners until all hours, rowdy drunken souls were roaming the streets and vandalism was rife. The saying that 'a policeman's lot is not a happy one' remains true to this day.

17

FULL STEAM AHEAD

The local folk who remember the glorious days of steam have been treated to something of a revival in recent times. The opening of the Ribble Steam Museum on the old dock railway in 2005, and the numerous steam-hauled excursion trains that regularly visit Preston, must bring back fond memories.

From early Victorian times Preston has been at the heart of the country's railway network, with lines converging from the east and west, from the north and south. The first railway in these parts, which connected Preston (from its Butler Street station) with Wigan, was opened on 31 October 1838, and involved the building of the North Union Railway Bridge over the River Ribble. Two other River Ribble bridges followed in the

coming years; the East Lancashire Railway Bridge opened in 1850 and incorporated a footbridge ideal for watching trains go by, and in 1882 the West Lancashire Railway Bridge opened to carry rail traffic to a new station at the foot of Fishergate Hill.

Railways began to have a significant effect on the Preston landscape. In May 1840 the Preston & Longridge Railway was opened, with its terminus being initially behind Stephenson Terrace in Deepdale, prior to a tunnel being constructed under Preston to take the line to Maudland. In June that year the town was connected with Lancaster, followed weeks later by the opening of the Preston & Wyre Railway between Preston and Fleetwood, which had involved the construction of the viaduct at the bottom of Tulketh Brow.

By February 1846 Preston and Lytham were united, and soon afterwards railway communication was established with Blackpool and Blackburn. In the same year, the Ribble Branch Railway (connecting the Preston quays with the Butler Street railway station) was completed. By this time, the first railway to Wigan had led to a link-up with Bolton via the Euxton Junction, and ultimately a link with Manchester where, in 1830 amidst great excitement, that place had been connected by rail to Liverpool. Add the Preston to Liverpool line in 1849, and a connection with Southport via Burscough Junction six years later, and the folk of Preston were almost spoilt for choice with seaside, country and city now just a train journey away.

There is no doubt that the development of the railways locally brought much employment to the area and an influx of labourers, including a large number from Ireland. The railroad workers' lot was hard and hazardous, and this was highlighted in May 1840 when bricklayers were rushing to complete the ninth arch of the viaduct at the bottom of Tulketh Brow. Suddenly, the half-finished arch collapsed, sending the men crashing to the ground with tons of brick upon them. Four were fatally injured and others were crippled for life.

The railway was certainly prospering and, as more travellers ventured from London to Scotland, the need for overnight accommodation was met by the building of the Park Hotel overlooking Miller Park. The hotel was ready for its first businessmen by Guild Week 1882, having cost £40,000 in construction. The approach to the hotel from the railway station was across an elevated covered walkway.

The increased rail traffic also meant that an upgrade for the Butler Street railway station was essential; it had previously been described by historian Anthony Hewitson as one of the most dismal, dilapidated, and disgraceful structures in Christendom. Formally opened in July 1880, the new station – along with a new bridge over Fishergate – had cost £250,000 in redevelopment.

At last Preston was able to cope with a railway system that saw 450 trains, both passenger and goods, arrive or depart every day. Such a busy station was bound to have its moments of disaster, though, and such an occasion was the second Sunday in July 1896. That evening, the record-breaking steam double-header, the 'Scottish Express', pulled by noted engines *Shark* and *Vulcan*, sped through Preston, bound for Aberdeen at 60 miles per hour. Unfortunately, it came to grief seconds later on the notorious curve close to St Walburge's Church, ending up a tangled wreck with one passenger dead and several injured.

The coming of steam was to leave many lasting memories, yet in the early days of the Preston to Longridge line (which had stations at Deepdale and Maudland), the carriages were drawn from Preston to Longridge by horses. On the return journey, owing to the downward gradient the carriages ran by their own momentum as far as Grimsargh station, from where horses were employed once more. It was not until June 1848 that the train was hauled by a steam engine, this being named *Addison* in honour of the chairman of the rail company, Thomas Batty Addison.

Forty years on, a private branch line from Grimsargh to the asylum at Whittingham was laid. This was run until June 1957, taking 12,000 tons of coal to the hospital each year and transporting 200 staff to Whittingham each day. Another rail service closure to hit Preston was announced in September 1963, when the controversial Beeching plan included the closure of the direct Preston to Southport line due to low passenger numbers and losses exceeding £120,000 per year.

In September 1960 there was drama north of Preston station, at the locomotive sheds in Croft Street. That day, one of the town's biggest blazes saw the sheds gutted by fire with twelve locomotives destroyed. The fire sounded the death knell for the sheds where thirty engines were normally based; operations were transferred to Lostock Hall.

The days of the steam engine were numbered and gradually they were taken out of service – much to the despair of trainspotting enthusiasts, who had clambered onto the wall at Pitt Street to see the engines go past. In February 1958, rail passengers on the Preston to Blackpool line had a taste of things to come when borrowed diesel unit

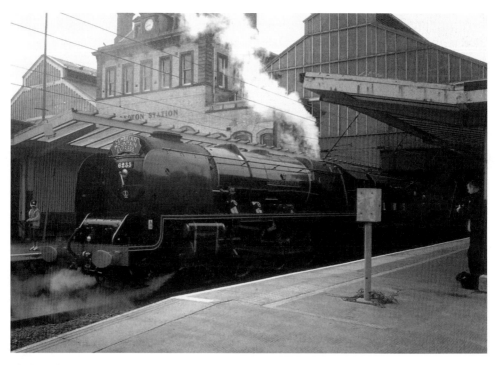

The 'Cumbrian Mountain Express' prepares to depart from Preston railway station in 2010.

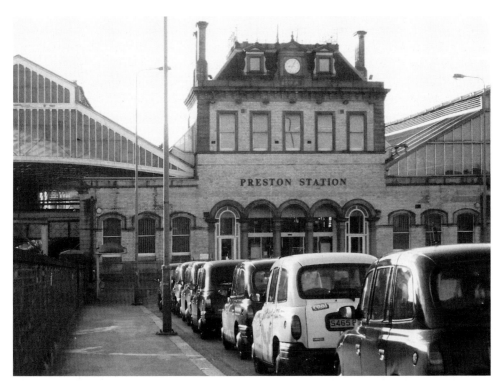

Butler Street railway station in 2010.

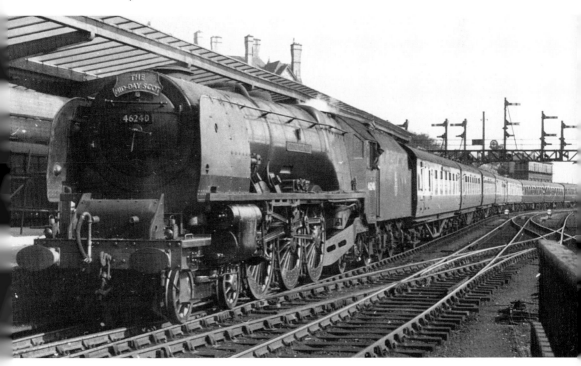

A familiar scene at Preston with 46240 *City of Coventry* arriving into Preston in June 1957.

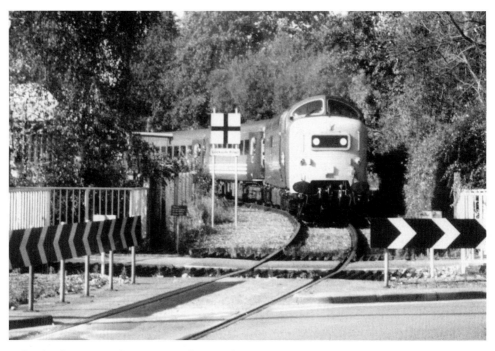

Deltic diesel 55022 *Royal Scots Grey* made a nostalgic trip to Preston in 2010 on the Ribble Railway.

trains were used to transport them to the seaside. It was a chance to sample the power of diesel motive units. In Preston in 1955, the English Electric works had been used to manufacture the prototype of the high-powered Deltic diesel locomotive, for use on the East Coast main line from 1961. Soon diesel locomotives would be operating on the London to Glasgow line that sped through Preston and, by July 1973, the electrification of the main rail route was complete.

August 1968 saw the last weekend of regular steam working on the British Railway network; that year saw a number of nostalgic journeys made by steam enthusiasts. The Fleetwood-based engine *Black* made a trip to Blackpool, with carriages packed with enthusiasts from Preston. Earlier in the year, thousands of trainspotters had packed the route from Fleetwood to see the Britannia class engine *Oliver Cromwell* steam past.

These days, the Preston station is run by Virgin Trains and upwards of a dozen trains arrive or depart each hour. This station became famous throughout the land for its free refreshment service to troops during both world wars. Hundreds of locals volunteered to quench the thirst of members of the armed forces with a welcome cup of tea around the clock.

If you visit the Butler Street station these days you are likely to see a Virgin Pendolino or Super Voyager heading to London or Glasgow, a First TransPennine Express DMU destined for Yorkshire, or even a Northern Rail Sprinter heading for the seaside. And, if you're lucky, you may just see a steam engine pulling a tour operator's excursion. The days of regular steam may have long gone, but Preston remains a significant place on the rail network of today.

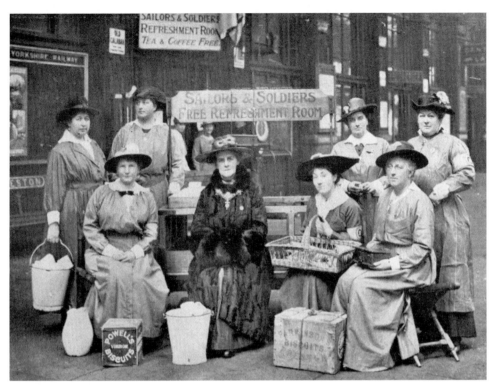

Preston station buffet. Free refreshments were provided for the troops at the Butler Street station during the First World War.

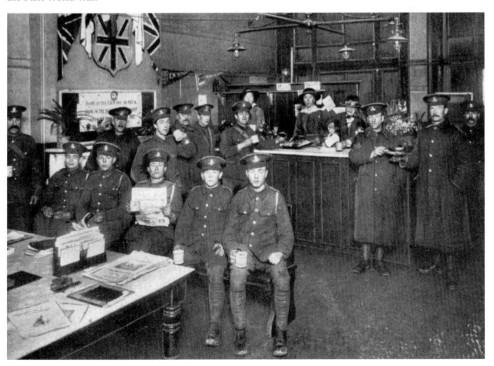

THANK GOD FOR CHURCHES

Preston is very proud of its church buildings and they are preserved whenever possible. A few years ago there was delight when the imposing landmark towers of St Augustine's crumbling church in Avenham were retained. With its Roman Ionic style of architecture, the church was a delight from its opening in 1840 until its forced closure over twenty-five years ago. Its conversion into a leisure and community centre ensured that it remained on the local landscape.

Wherever you wander in Preston, you are sure to come upon a church. It is not surprising, since in Saxon times it was known as Priests' Town, being the abode of a number of priests and containing much property within its boundaries belonging to certain ecclesiastics. In the year 1821, according to the historian Peter Whittle, the town was rightly proud of its public structures devoted to religious purposes. The churches were described as simple but elegant, with the parish church of St John being the most worthy of praise. For over 1,000 years a church had stood on this site, being first constructed of wood, roughly hewed and carved. Along with its sister chapel of St George (built in 1723 on Friargate), Trinity Church (erected in 1814 on Patten Field), and the churches of St Paul and St Peter in the course of construction, these buildings served the spiritual needs of the town's Church of England congregations.

The Roman Catholics, struggling to recover from the Reformation, had at this time two places of worship: the chapel of St Wilfred's, first opened in 1793, and the chapel of St Mary's on Friargate Brow, opened a year earlier.

Methodists, no doubt inspired by the legendary preacher John Wesley – who preached four times in the town – had their Wesleyan chapel in Lune Street, built in 1817. Add a Presbyterian chapel in Fishergate, an Independent chapel in Grimshaw Street, the St Paul's chapel in Vauxhall Road, a Baptist chapel in Leeming Street, the Unitarian chapel on Church Street and the Quaker's very own Friends Meeting House on Friargate, there was plenty of choice for a population of some 17,000 folk.

Of course, the cotton trade was in the throes of development and, during the next century, as the mills and factories grew, so did the churches and chapels. It is apparent that religion played a major part in daily life, and the Sabbath was to be strictly observed.

By the time the First World War was upon us, there were twenty Church of England churches in Preston, with another eight to be added in later years. It was estimated at the beginning of the twentieth century that over a third of the town's population was of the Roman Catholic faith, with seven places of worship to choose from. Another eleven Catholic churches were built in the twentieth century and there were plenty of places, within the old borough boundaries, to hear daily Mass.

For those not of Catholic or Protestant persuasion, there was plenty of alternative religious worship. Known collectively as 'nonconformists', these included Wesleyans, Baptists, Quakers, Unitarians, Evangelicals, Mormons, Primitive Methodists,

Left: The doors to St Mary's Church, off New Hall Lane, closed for the last time recently.

Below: The abandoned St Paul's Church is now home to Rock FM.

Methodists, Christian Scientists, Spiritualists and the Salvation Army. Their places of worship varied from church buildings to humble mission huts and, in the early part of the twentieth century, over forty such places still existed.

Church building was lavish and many an imposing structure graced the local scene. Spires and bell towers reached up to the sky and the monuments were testimony to the faith of the Preston folk; the religious fervour left a legacy to be richly guarded.

Of course, times and beliefs move on, and a number of cherished churches have fallen on hard times during the last century. However, preservation is to be encouraged and there are many fine examples in recent times.

The Revd Roger Carus Wilson was vicar of Preston for over twenty years in the early nineteenth century, and was responsible for overseeing the construction of

Christ Church on Bow Lane is today a conference centre.

a number of Church of England churches. However, if he looked down from his heavenly abode now, he would see much change to his dedicated exertions. Following the recent closure of St Mary's Church, only the Church of St Andrew in Ashton remains of his legacy as a place of worship. St Paul's Church (facing the ring road) is now rocking to the beat of local radio station Rock FM, St Peter's is now an Arts Centre integrated into the life of the university, Christ Church retains only its frontage and is a conference centre, St Thomas's on Lancaster Road spent the last twenty years caring for the needs of Age Concern and recently reopened as a Pentecostal church, whilst the magnificent tower and church of St James that dominated Avenham Lane was demolished in 1983, with porous stonework and dry rot abounding.

The Trinity Church, once a Gothic architectural delight to the Church of England congregations, was demolished over fifty years ago, and only the old gateway pillars remain to remind people of this car park's former status. In more recent times, campaigners helped to save another Gothic-style church when the threatened St Marks, with its lofty location, was saved by its conversion into self-contained flats. Alas, no amount of campaigning could save the Unitarian chapel, the city's oldest nonconformist building on Church Street. Empty and derelict from the 1970s, it was eventually swept away in the recent development of the area. Likewise, the old church building of St Stephen's was demolished, and St Jude's Church suffered a similar fate when its once sacred ground was used for luxury apartments.

Roman Catholics have also lost one of their flagship churches to tarmac and parking tickets, with only a shrine to Our Lady remaining to remind visitors that, for almost two centuries, thousands worshipped at the Church of St Mary on the brow of Friargate.

Methodists too have seen conversion of their churches to alternative use, an example being the Moor Park Methodist Church on Garstang Road. 'For Sale' signs were posted there in 1984; for a while it became a Muslim centre, and later the Antique Centre, home to treasures from the past. An office block now occupies the land once taken by the Cannon Street Congregational church, the Market Hall stands where the Orchard Chapel once stood, whilst the old Saul Street church is now the Masonic Hall building just off the ring road.

Nowadays, mosques and temples are also among the city's places of worship, as Christianity lives side-by-side with the beliefs of the Muslim, Hindu and Sikh.

There is no doubt that the numerous church buildings that remain are a cherished feature of our landscape. A strange place it would seem indeed without the likes of our recently restored parish church, the tall steeple of St Walburge's, the clock tower of Fishergate Baptist church, the tower of Emmanuel Church with its illuminated cross, the bell tower of St Mark's, the steeple of St Ignatius' and so forth.

Let not the old verse return:

Proud Preston, poor people,
Ten bells and an old cracked steeple.

HALLOWE'EN HAUNTINGS

Each year, as Hallowe'en approaches, talk inevitably turns to ghosts and it is claimed that the spirits are awakening for their night of mischief. What could be stirring in our old town – new city – on a night such as this? Will Preston's legendary Bannister Doll make a fleeting appearance in the Maudland area of town? This daughter of a prominent townsman is said to haunt old Ladywell Street and its neighbourhood. According to legend, Dorothy Bannister fell foul of her outraged father after telling him that she was with child. In his anger, he bound and whipped her till the very life flowed out of her and her unborn baby. Discovering later that the girl had been forced into the act that violated her, he spent his years in grief, ever remorseful at the tragic end of an innocent girl's life. So, if you venture out that way and hear footsteps behind you, be not afraid of the ghostly apparition in white dress and bonnet that follows you. It means you no harm.

Gallows Hill has brought forth tales of eerie activity ever since the days when Jacobites fought their cause and were forced to surrender there. Where once the Gallows Tree stood now stands English Martyrs' Church, and all evidence of headless human corpses is buried deep in Preston's history – yet tales continue of the terror

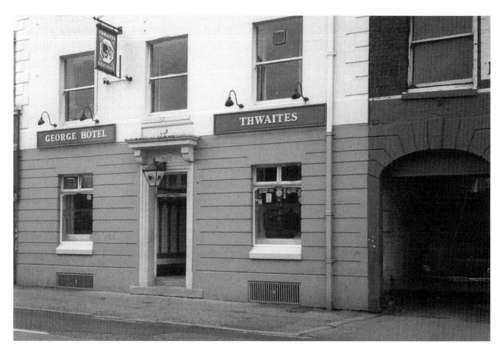

The old George Hotel in Church Street – the haunt of Robert Clay – *c.* 1990.

of the Black Dog of Preston. The Victorians lived in fear of meeting this headless, howling boggart, whose howl was said to mean certain death. Prestonians feared this huge and hideous creature, which had been seen pawing the air and swaying from side to side. The belief was that if the Black Dog was observed lying on a doorstep then woe betide the dwellers within, because one was about to die.

Down Church Street, one of Preston's ancient thoroughfares, visitors are cautioned to be wary of the old George Hotel building, said to be haunted by one Robert Clay, an alleged child murderer. Landlords have been left fearful after glimpsing a tall, gaunt figure dressed in Victorian clothes, heading for the cellar where, it is claimed, his innocent victims were buried.

If you venture down Glovers Street be cautious, and perhaps quicken your stride, for not many years ago the landlady of the Wellington Tavern felt a strange presence in her midst when recalling a tragedy of 1839, when one of the inn's customers was slain due to a quarrel over a penny piece.

On New Hall Lane, you may prefer not to loiter as you pass the former Horrockses Mill, because on the next corner once stood a local butcher's shop where, early in the twentieth century, the butcher's wife met a bloody and untimely end at her husband's hand. In later years, it was reported that a workman had been horrified when the phantom of a woman shrouded in flowing white satin appeared as he worked on the premises.

Some say that if you walk under the railway viaduct, at the bottom of Tulketh Brow, you may hear the harrowing cries of those engulfed in the tragedy of May 1840, when the ninth arch of this Victorian structure crashed to the ground whilst in construction. The sixteen men and boys who were at work that day were buried beneath the tons of bricks and mortar; four perished and others were left crippled for life. Work continued within days to complete the Preston & Wyre Railway connection, but the anguish of that traumatic afternoon lived on and is still felt from time to time.

The disused railway track and tunnel close by the old Deepdale railway station is also a favourite haunt for those who seek bloodcurdling cries of horror. On one Sunday afternoon in December 1866, a group of schoolgirls congregated on the platform; tragically, teenager Maggie Banks slipped onto the track, where she was crushed to death beneath the carriage of a steam engine. The girls screamed and shrieked in distress, their cries echoing through the nearby tunnel.

If you hear the rattle of bones as you walk towards the end of Walker Street, you might be hearing the skeleton of Jane Scott, back in her favourite haunt. Early in the nineteenth century, she gained local notoriety after poisoning both of her parents with a bowl of arsenic-laced porridge. She was subsequently hanged at Lancaster Castle; in later years her skeleton was bought at auction for a few shillings by a shop owner in Walker Street, who displayed it in a coffin-shaped box in his parlour. For a farthing or two, visitors were allowed to view the bones of a killer.

Even the Town Hall merits a mention when the question of spirits is raised. A few years ago there was talk of a sinister figure seen making his way up the staircase. Like a Dickensian character, he was said to have long, grey, flowing locks and wear a brown coachman's overcoat.

Of course, if you think the safest bet is to head out of the city, beware which route you take. If heading towards Fulwood, perhaps you'll glimpse the barracks there. Twice the scene of tragic killings, it is said to have a ghost all of its own. Some have seen the figure of an unknown soldier standing by the lectern in the chapel.

If you should head towards Blackburn on the old Preston Road then take care, as the elegant apparition of Lady Dorothy of Samlesbury Hall has apparently distracted a motorist or two. Dorothy, whose suitor was slain by her brother, was – according to the tale – sent to a convent, where she died of a broken heart.

Head not for Goosnargh either, for there stands Chingle Hall, claimed in its time to be the most haunted place in Lancashire. Once inside you may glimpse the shadowy figure of a monk, or some other hooded figure kneeling at prayer.

Be cautious too if travelling along the A675; keep well clear of Hoghton Tower, for within that place several spirits are said to roam. The most legendary ghost is Ann, a daughter of the de Hoghton's, who, dressed in green velvet, seeks the lover she was denied due to differences in faith. It is said that her spirit is never far from the great Banqueting Hall.

Preston Town Hall.

Fulwood Barracks, the scene of tragic killings.

If you are heading through Woodplumpton and glance towards the graveyard there, you will see a large boulder stone. Pray that the boulder does not stir, because buried face-down beneath is said to be Meg Shelton, a witch of local notoriety. Meg Shelton is just one of a clutch of Lancashire witches, many of whom faced trial at Lancaster Castle – including the so-called Samlesbury witches and those of Pendle Hill infamy.

If you are travelling past the Stone Bridge Brow on the road to Garstang, and hear the sound of galloping horses, then take heed. It was along that way in 1863 that a wagon carrying a boiler overran its horses; three horses and their drover perished.

Should Chipping be your destination, then you will hear of the ghost of Lizzie Dean. It is yet another tale of young love forsaken, a broken heart jilted at the altar. Apparently, the Sun Inn is Lizzie's favourite haunt.

In Much Hoole you'll be told a tale of mischief made with a coffin. As Hallowe'en approached in 1858, some local youths set out to play a prank on the local schoolgirls. So convincing was their act that one poor girl died of fright.

However, be not afraid – things are often not as they appear. Remember that in 1768, folk down Stoneygate way were fearful when noises like 'the devil playing his bagpipes' were heard, coming from what is now known as Arkwright House. There were no spirits making merry, only young Richard Arkwright attempting to perfect his spinning frame.

Imagination can run wild on a night like Hallowe'en, so keep yours in check. What the heck, just bolt the door, stay by the fire and think of fulfilling things. Remember that ours is the 'Priests Town' for good reason; of course we're blessed with goodly souls and will survive till morn, when All Saints will have their day once more.

DAWN OF THE DEAD

From time to time, the local authority comes in for criticism with regards to the upkeep and maintenance of the Preston Cemetery in New Hall Lane. In recent years, great efforts have been made to maintain the burial grounds to a high standard – a task made ever more difficult by wanton vandalism. With the aid of the Wildlife Trust, the authorities have endeavoured to make the place as pleasurable as possible.

The cemetery has Victorian origins, the first interment having taken place on 2 July 1855, when Elizabeth Frances Christian, aged just five years, was laid to rest.

With the enforced closure of the many parish graveyards attached to town centre churches, the new cemetery was a busy place – over 65,000 local folk were buried within before thirty years had elapsed. In 1883, Anthony Hewitson had the following to say on the matter in his newly published book: 'The walks are in good order, the grounds well cared for; and in the summer time, with its trees and shrubs and flowers, the Cemetery looks beautiful – if one can apply such a word to such a place.'

This certainly seemed like a step forward after the criticism of thirty years earlier, when letters to the local newspaper had talked of an unhealthy situation in town when the seventeen local graveyards, with their mass graves for paupers, had been full to overflowing. In St Paul's churchyard, an open grave was on display with seven coffins interred – and space for another twenty corpses before closure.

Of course, many of our local graveyards have been swept away in the forward planning of our city, with the remains being transferred to Preston Cemetery – often a hundred years or more after interment. No longer on display is the cracked gravestone under which Samuel Horrocks (he of cotton fame) was laid to rest, nor is the grave of Nicholas Grimshaw – seven times Mayor of Preston – visible to visitors to the parish church.

Preston Cemetery, which opened in 1855.

Monument to Temperance Pioneers in Preston Cemetery.

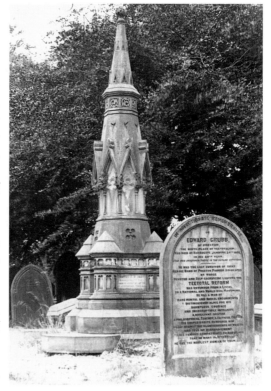

If you should venture forth into the Preston Cemetery, though, you can still marvel at some of the stone masonry and be intrigued by the chiselled messages from the past. Graves here include that of Thomas Duckett, who sculpted the statue of Robert Peel; Annie Kelly, a maid who was slain by her sweetheart; war hero Private William Young; Joseph Livesey, who led teetotallers in their quest; and, beneath an imposing family vault, lie the remains of Matthew Brown, who built a brewing empire to quench the thirst of the cotton workers of Lancashire. (*See* Chapter 4 for more details on these graves.)

One of Preston's first footballing heroes was Nicholas John Ross, who earned a reputation as the finest fullback in the country. His untimely death in 1894 stunned followers of the North End, and a public subscription paid for the stone that marks his grave.

Many gravestones record the tragic and fragile lives of the past, when infant mortality was a constant concern and countless families lost their offspring to the childhood diseases of the time. It was a common occurrence for families to visit the cemetery at weekends. Trams, and later buses, made regular trips to the cemetery gates for the benefit of those who wished to visit the graves of family and friends.

In its first 130 years, close on 250,000 bodies were interred in over 40,000 graves within the old and new cemeteries, at a time when cremation was not considered a serious option by most of the population.

Preston-born poet Robert Service reminded us all of our mortality when he wrote the following words in his poem 'Just Think':

Just think! Some night the stars will gleam,
Upon a cold, grey stone,
And trace a name with silver beam,
And lo! 'twill be your own.

Many of the great and good of our city have been buried within Preston Cemetery, may they rest in peace.

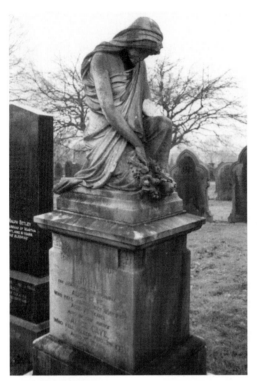

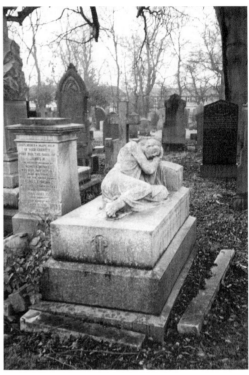

Above: Memorials to the dead in Preston Cemetery.

Left: Poet Robert Service (1874-1958). In verse he reminded us all of our mortality.

GRAVE MATTERS ONCE MORE

It seems that whenever developers start digging in Preston, they unearth an old burial ground – such as the one situated in St Wilfred's Street, beneath a temporary car park, revealed in the summer of 2009. It appears that our ancestors will never be left to rest in peace.

Prior to the opening of Preston Cemetery in July 1855, there were numerous burial grounds within the old Preston borough boundaries. When the cemetery opened, all of the existing graveyards – with the exception of those at St Ignatius' and St Augustine's – were closed, those two following suit within a couple of years.

Campaigners had battled long and hard to have the new resting place, the problem having been highlighted back in 1849. A correspondent to the *Preston Guardian* had drawn attention to the fact that, in the space of fifty years, 40,000 bodies had been interred within the precincts of the town. In all, he remarked, the grounds of seventeen churches and chapels were continually reeking with the stench of death. In paupers' graves body had been piled upon body, with up to forty coffins in an open grave. In particular, he drew attention to the graveyard of St Paul's Church, close by his home, where many of the poor were buried. On a summer's night, when a westerly wind blew, he was compelled to keep his windows shuttered to prevent the pestiferous odours from the graveyard entering his dwelling.

Graveyards were dotted around the densely populated town. There was a small graveyard attached to the Unitarian chapel, situated between Church Street and Pole Street. Used from 1717, it contained the bodies of many early worshippers and had a stone monument to the Ainsworth family.

Towards the end of Church Street is the graveyard of St John's parish church, where a flat gravestone recorded the passing of Thomas Myres back in 1670. A reminder of the dreadful malady typhus fever is recorded in the fact that, in December 1813, no less than fifty souls were laid to rest in this burial ground – all victims of the dreaded sickness. Even this sacred ground has undergone a transformation, with the tombstones now laid flat and churchgoers permitted to park their cars upon them. Only a couple of monuments remain to remind you of the souls once buried beneath.

At the bottom of Lune Street stands the chapel dedicated to St George. The graveyard area has been renovated in recent times and many of the gravestones have been removed or repositioned, including the cracked gravestone of Samuel Horrocks. The original chapel was erected in 1723 and numerous local dignitaries were buried within the grounds, including physician Richard Shepherd, who was twice Mayor of Preston in the eighteenth century.

If you choose to park your car in the Trinity car park on Market Street, note that Trinity Church once stood there; the graveyard on the old Patten Field was an impressive one, with northern and southern entrances graced by ornamental Gothic pillars.

St George's graveyard, where Samuel Horrocks is buried.

Within the university complex now is the former church of St Peter's which, from 1825, was surrounded by its own vast graveyard. In the southern corner of the churchyard is a grave containing the remains of several teetotallers. It carries an inscription to the memory of Richard 'Dicky' Turner, who was the author of the word 'teetotal' and whose body was buried therein.

On Bow Lane stands the County Council Conference Hall, built in 1971 on the site of the former Christ Church. The graveyard that adjoined this church was used from 1838, with 155 burials taking place. During the redevelopment, the bodies were removed and re-interred in Preston Cemetery.

In 1982, St Paul's graveyard was revamped as the old church building became a radio station. Many of the tombstones were moved and, despite landscaping of the grounds, the human remains were left undisturbed.

St Walburge's Church with its landmark spire, and the Maudland Estate, are built on the site of the thirteenth-century ancient hospital of St Mary Magdalen. In 1836, whilst workmen were excavating the area, they discovered five skeletons and a mass of human bones, along with a stone coffin.

The burial ground surrounding St Ignatius' Church still remains on Meadow Street, but in 2003 the remains of a couple of thousand souls buried in St Augustine's Church graveyard were dug up and transferred to a plot in Preston Cemetery, as that church was transformed into a sports centre.

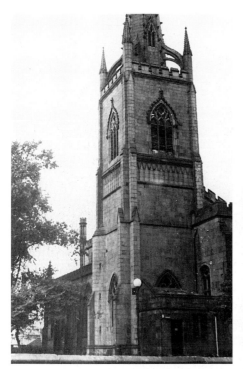

St Peter's graveyard, the last resting place of Richard 'Dicky' Turner.

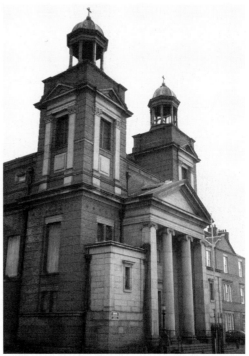

In 2003 the remains of those buried in St Augustine's Church graveyard were moved to Preston Cemetery.

Add the graveyards associated with the churches of St Mary's (off New Hall Lane) and St James' (which once stood on Avenham Lane), and, considering there were graveyards associated with the dissenting chapels in Vauxhall Road, Leeming Street and Grimshaw Street, plus the Friends Burial Ground, it is no surprise that remains are often unexpectedly unearthed in the old borough boundaries.

The Fox Street Burial Ground was always mysterious. Surrounded by a high wall, it was the last resting place of a number of notable Roman Catholics. Reportedly, very few had the fortune to visit it, and many an historian yearned for a peep inside its walls. Amongst those buried there was the notable Peter Newby, an early Catholic printer and bookseller. He lived his life as a bachelor and, when he died in 1829, aged sixty-two, his epitaph recorded the following:

> Here lies Peter Newby,
> A stranger to fame,
> Obscure was his life,
> Less known was his name,
> A sailor, a farmer, a poet, a teacher,
> His friends would gladly have made him a preacher.

Builder beware, for you know not what lies beneath our ancient soil.

FULWOOD – PRIDE OF PRESTON?

Fulwood is now very much part of the sprawling City of Preston. Of course, that has not always been the case for an area that got its name when forests covered much of the North West. Indeed, during the period when the Romans occupied Britain, a road was made through this damp and boggy wood that stretched from Kirkham to Ribchester, along the route of the present-day Watling Street Road.

In the period following the Norman Conquest, Fulwood became part of the vast forest of Lancaster and was reserved for hunting for the noble folk. Eventually, thanks to a Royal Charter, the good people of Preston were granted permission for free pasturage and for the removal of timber for the construction of dwellings. Inevitably, the privileges were abused and folk from the Fylde were soon helping themselves to the wood – and in some cases settling within the area. Much of the forest was laid bare and Preston had to fight long and hard to maintain its legal entitlement. In consequence, the burgesses of Preston were eventually given 150 acres on the border between Fulwood and Preston, in return for relinquishing their ancient rights.

By the end of the eighteenth century, the map-makers of the time had Fulwood Moor stretching from Cadley Moor to the west through to Fulwood Row at the east. Up to the middle of the nineteenth century, Fulwood remained an entirely rural region, being mainly agricultural land with farmhouses and cottages scattered about the landscape. It had been decided back in 1817 to create the Fulwood Enclosure, to get the best from farming the land to feed the growing population in cotton town Preston. Longsands Lane, Fulwood Hall Lane and Watling Street Road were all developed to service the enclosure. Within the area eventually was Fulwood Barracks, which was completed in 1848 on land originally owned by the Crown (this land was used earlier for the horse racing, backed by Lord Derby for over forty years).

The area that – by the end of the nineteenth century – would contain most of the population of Fulwood was known as 'The Freehold', being part of the movement that created the 'Freehold Land Societies' throughout the nation. The land they acquired for £5,000 was formerly known as Horrocks Farm and was of 45 acres; lots were drawn by shareholders of the society in the Temperance Hall in Preston.

In reality the progress in building was slow; it was some years before the first house was completed, this being known later as 18 Victoria Road, on the north side – opposite the entrance to Higher Bank Road. The properties built varied from farm cottages to spacious detached homes, and the development of Fulwood Park was overseen by Richard Veevers, one of the estate architects who had No. 17 Lower Bank Road, known as 'The Priory', erected for himself. Amongst the trustees of this fledgling society was Joseph Livesey, head of the Temperance Society, so it was no surprise that there were no plans to increase the number of public houses in the area – unlike the parent town of Preston, where a public house appeared to stand on every street corner. After all,

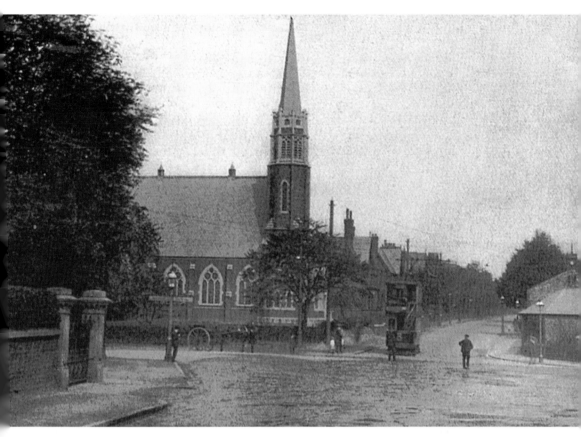

View from Withy Trees, *c.* 1920.

Fulwood already had the Black Bull and Withy Trees from toll-bar days and, closer to the estate, the old Prince Albert Hotel (which later took the name of Sumner in recognition of the local brewer William Sumner) and the Royal Garrison on the opposite corner – both being ideally situated to quench the thirst of soldiers from the barracks.

Fulwood has, over the years, developed a number of historical landmarks, such as the old Fulwood Workhouse with its clock tower, opened in 1868; the premises of the Little Sisters of the Poor; the Harris Orphanage, built on land known as the Crow Trees and opened in 1888; and the former Home for the Blind at the corner of Black Bull Lane, completed in 1895. Around this time the golfers of the area started the Fulwood Golf Club, which soon amalgamated with Preston Golf Club. Fulwood Lawn Tennis Club had opened in 1891 and, with Fulwood Bowling Club having started in 1872, there were plenty of sporting pastimes to suit the genteel folk who came to Fulwood.

The opening of the workhouse left locals feeling uneasy with the influx of poor people, and extra police officers were drafted into the area. In 1871, the Lancashire County Constabulary gave the go ahead to the opening of a police station on Watling Street Road. In 1876, a number of residents volunteered to form the Fulwood Fire Brigade and, by the start of the twentieth century, they operated from Lightfoot Lane.

Fulwood Workhouse opened in 1868.

Fulwood was not neglected in terms of transport links to Preston; a horse-drawn omnibus frequently ferried locals to town and in those days, when trams were all the rage, Fulwood was well provided. In March 1879, the tramway from Preston to Fulwood was opened. This particular tramway ran from the centre of town to the then Prince Albert Hotel and, in later years, the loop took passengers to the Withy Trees.

To govern this growing suburb a local board was formed in 1863, when the population was less than 3,000, and, from 1894, Fulwood was an independent urban district council. All that changed in 1974 when, with a population of 22,000, it relinquished control to Preston as part of the government reorganisations. During their final days of control, the urban council rejected planning permission for twenty-four flats and thirty-seven maisonettes in Lower Bank Road, and for nine flats in Garrison Road.

Since becoming part of Preston Corporation, Fulwood has expanded and, besides the numerous housing estates that have encroached on the fields of old, there have been other significant developments. Back in 1976, new Preston College buildings became fully operational in St Vincent's Road and the expansion continued into the twenty-first century. On the shopping scene, E.H. Booths the grocery firm, begun by a pioneering

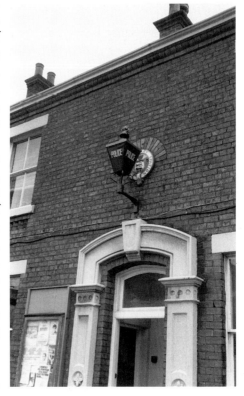

The blue lamp on Fulwood police station.

Preston grocer, replaced their small store at Fulwood with the Booths Shopping Centre at Sharoe Green, which opened in 1978.

Throughout the decades, the Sharoe Green Hospital saw the birth of generations of Preston folk, and as recently as forty years ago a £2m project saw the hospital extended. A decade later, when plans were drawn up for the Royal Preston Hospital, a site at Fulwood – a 47-acre plot off Sharoe Green Lane – was earmarked for the development. The hospital was up and running by January 1981, and was officially opened in June 1983 by HRH the Princess of Wales, who chatted to patients and staff alike.

There is little doubt that Fulwood has developed at quite a pace, yet it still remains one of the more desirable suburbs of Preston and, if the Conservation for Fulwood lobbyists get their way, it is likely to stay that way.

23

BYPASSING BROUGHTON

It seems that the debate regarding the bypassing of Broughton, an apparent problem since the arrival of the motorcar, will never be resolved. Indeed, the 21-mile stretch of the A6 highway from Preston to Lancaster still carries heavy traffic – despite the construction of the M6 motorway, which was opened in late 1958 – and the junction at Broughton remains notorious for traffic hold-ups.

It seems that folk have always had the aim of bypassing Broughton, giving the impression that it is a place to avoid. However, early in the twentieth century, the historian Anthony Hewitson, who travelled along the A6 compiling the notes for his book *Northward*, described the highway as the most interesting road in the kingdom. He observed that Broughton village was made up of a few cottages, a shop or two, some joinery and blacksmith sites and a couple of public houses. Hardly the kind of place to avoid.

Of course, when Hewitson travelled along this highway things had improved somewhat on the reflections of a traveller of 1770, who remarked that it was an infernal road, which he cautioned travellers to avoid as they would the Devil. He remarked that there were 4ft-deep ruts, floating with mud. The highway generally had a span of some 6ft, bordered with high hedges and paved with round pebbles, and was listed as a turnpike road by the government in 1760. The Broughton section of this toll-paying road extended for almost 2 miles, and toll collectors were always busy gathering the money. In fact, by 1826 it would have cost you sixpence for a horse drawing a carriage and ten pence to drive a score of sheep along its length. The Toll Bar Cottage still remains, just before the junction, encroaching onto the present-day pavement.

Toll Bar Cottage.

In 1828, when more highway improvement work was planned for the A6, surveyor William Thornborrow arrived from Wales, where he had been working for the great civil engineer Thomas Telford. In charge of the improvements, Thornborrow rented Bridge Cottage, facing Broughton Church, so that he was on hand day and night. In fact, he got so attached to the place that he ended up buying it and living there for forty years until his death.

In the middle of the nineteenth century, Broughton had a population of no more than 600, and growth was slow despite the great increase in the number of people in the cotton town of Preston. Population growth in both the urban and rural parts of Broughton was slow even between the two world wars, when houses were only built at a rate of fifty per year.

It was the coming of the combustion engine in the early twentieth century that heralded the start of the traffic problems at the four lane ends. Even the local constable was soon mechanised, using an early Norton motorcycle for patrol duty. Also patrolling the highway was a mechanic from the Royal Automobile Club. For almost thirty years after the First World War, Mr Barfoot rode his bicycle up and down the highway, happy to help stranded motorists.

Through the years, many a traveller has seen their progress halted as they reach the Broughton traffic lights and the junction has become familiar to many – having two public houses on diagonally opposite corners probably helps to keep the memory alive. These days, both public houses cater as much for the diner as for the drinker. The Gate of Bengal was formerly the Bay Tree and earlier the Golden Ball, and Burlington's Dining Rooms was originally the Shuttleworth's Arms and later Trader Jacks. The name

Burlington's Dining Rooms, a popular restaurant.

Broughton traffic lights; a traffic bottleneck.

Shuttleworth is a reminder of the days when James Shuttleworth was the Lord of the Manor. This inn has played a significant part in village life, being used for inquests, meetings and social gatherings, and in 1933 the local Masonic lodge was formed there.

In the summer of 1956, traffic lights were installed in an attempt to solve the problems of the notorious Broughton crossroads and its traffic jams. Operated by a policeman, they proved a big success over the Whitsuntide weekend as the large amount of holiday traffic was kept flowing. For the first time, the Lancashire County police had the use of a helicopter to identify any traffic hold-ups, with the A6 from Preston to Lancaster being monitored all weekend. In the days before the M6 motorway, the traffic to and from Scotland would grind to a halt at the junction, as holidaymakers from East Lancashire, heading for the Fylde coast, would cut across its path.

In December 1958, a significant milestone was reached in travel when the first stretch of the M6 motorway was opened from Bamber Bridge to Broughton – but it did little to ease the traffic heading for the Broughton crossroads. Until the motorway was eventually extended to Lancaster, there was an increase of problems with the traffic from the new Broughton roundabout heading north, or from people wanting to head to the seaside. Likewise, the M55 through to Blackpool, with its M6/M55 interchange at Broughton, was eventually essential to accommodate the ever-increasing volume of traffic. This motorway opened in July 1975, just weeks after a spectacular event when a BAC Jaguar took off from the carriageway near to Weeton.

Broughton Junction is still one to be avoided, as the volume of traffic on the roads increases year on year. Tailbacks from the traffic lights delay many an outing in the summer, and the journey home is often delayed.

Whenever new developments are planned in the area, thought is given to the problems likely to be caused at the heart of Broughton village. For example, plans to redevelop the former Whittingham Hospital site, on the edge of Goosnargh village, raised concerns about the increase in the volume of traffic caused by the new residents. Similarly, one of the reasons behind the bid to refuse permission for three coarse fishing lakes near Goosnargh was the fear that more traffic would increase the burden on Broughton's crossroads.

24

WHO WERE THE INVINCIBLES?

Cotton town Preston will forever be grateful to the footballers of Preston North End, who earned their place in the soccer record books. Fittingly, when the final stand in the new Deepdale Stadium was opened in August 2008, it was named after the Invincibles. Their achievement in gaining both Football League and FA Cup glory at the end of season 1888/89 ensured Preston's place in any roll of honour.

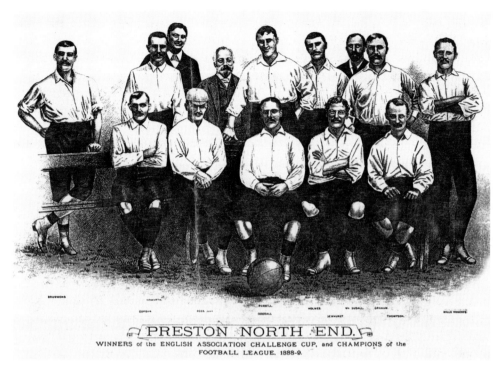

PRESTON NORTH END.

WINNERS of the ENGLISH ASSOCIATION CHALLENGE CUP, and CHAMPIONS of the
FOOTBALL LEAGUE, 1888-9.

Preston North End, Champions of the Football League 1888/89.

Who exactly were the players who earned the tag 'Invincible' under the guidance of William Sudell, both chairman and manager? In the immediate years before the Football League was formed, Major Sudell had realised the need to attract quality players, particularly those from across the border in Scotland, and was prepared to pay them a hefty sum to join the paid ranks at Deepdale.

Despite a couple of skirmishes with the authorities over paid players, by season 1886/87 Major Sudell had gathered a highly talented squad and they fought their way to an FA Cup semi-final against West Bromwich Albion. That match at Nottingham, on a Saturday afternoon in March 1887, drew over 15,000 spectators, who lined the perimeter ropes as Preston North End – with thirty-three victories and a goal difference of 198-35 from thirty-seven matches – took the lead. Alas, the Albion rallied strongly, were level at half time, and by the finish had defeated North End 3-1.

Undaunted, the North End team had county glory on their mind, with an appearance in the Lancashire Senior Challenge Cup Final at the end of the month. The two semi-finals had seen the North End send Witton crashing to a 12-0 defeat at Bolton, whilst Bolton had gained a 4-0 victory at Deepdale against Padiham. Although the final was played at Pikes Lane, the home of Bolton Wanderers, the North End soon got in their stride and were 3-0 up by half time. Preston continued to have the upper hand in the second period, and the Bolton goalkeeper made a couple of last-ditch saves. So, PNE grabbed their first piece of silverware, watched by a crowd of over 16,000 spectators. Not a bad season overall, with Deepdale gate

receipts of £2,396 and, after the payment of expenses and players' wages, a healthy profit of £156.

The following season began with North End amongst the favourites for the FA Cup, and a run of eight successive wins was followed by a record-breaking FA Cup victory of 26-0 against Hyde United at Deepdale. The Invincible team was beginning to take shape.

By January 1888, the North End had recorded twenty-four successive victories, scoring 143 goals in the process, and they travelled to Perry Bar to face Aston Villa in an FA Cup fifth-round showdown. Over 20,000 crammed into the enclosures, as Villa – with only one defeat from twenty-nine outings – kicked off. Villa took the lead early on, but, just before the interval, Fred Dewhurst levelled the scoring. Encroaching spectators had caused a number of delays and, for the second half, soldiers patrolled the touchlines. Preston pressure paid off just after the hour, when Jimmy Ross hit a low drive into the net. A few minutes more and John Goodall had made it 3-1 to PNE. Frantic play followed from Aston Villa, and only the trusty boot of Nick Ross saved the day on a couple of occasions.

A 3-1 victory away to Sheffield Wednesday in the quarter-final was followed by a semi-final clash with Crewe Alexandra at Liverpool, a hat-trick by John Goodall being the highlight of a 5-0 victory. It meant the North End, enjoying a record run of thirty-seven successive victories, still had hopes of national and county cup glory.

For the FA Cup Final, the North End went into special training for a fortnight, arriving at the Oval to face West Bromwich Albion full of confidence. As in the semi-final, the North End had recruited the services of Dr Mills-Roberts as goalkeeper. For many local folk it meant an afternoon outside the LEP newspaper office in Fishergate, where updates were posted on the window. Anxious expressions replaced the cheers when it was announced that Bayliss had put the Albion ahead after seventeen minutes. Then, some forty minutes later, there was a great cheer when it was revealed that Dewhurst had equalised. Satisfaction was felt a little later when it was announced that the scores were still 1-1 midway through the second half. The final result was eagerly

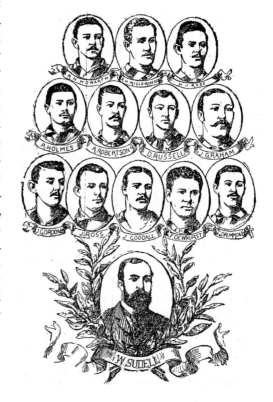

Glory beckoned for the Preston North End players.

awaited, but when it came heads shook in disbelief: Woodall had kept the FA Cup in the Midlands with a winner ten minutes from time.

In the Lancashire Challenge Cup, the North End won their place in the final with a convincing win over Darwen, but a row with the Lancashire FA over the choice of ground for that final led to a no-show by North End, and a trophy-less season despite their record-breaking football.

By the start of the season 1888/89, the North End had lost influential skipper Nick Ross to Everton; they nonetheless fielded a strong-looking eleven for the first ever Football League match. It was a home fixture against Burnley, which they won 5-2, watched by 6,000 spectators. Victories were commonplace for this team, so much so that by early January 1889, a 4-1 home victory over Notts County earned them the First Division title, with sixteen victories and three draws leaving them clear champions.

Unlike previous seasons, the elite sides such as North End only entered the FA Cup at the latter stages. Bootle were beaten first by 3-0, then Grimsby despatched by 2-0 before Birmingham St George visited Deepdale to be overcome by 2-0. In the semi-final, it was a time for sweet revenge as cup-holders West Bromwich Albion were defeated by a David Russell goal. Preston's opponents at the Kennington Oval were the Wolverhampton Wanderers, who had defeated Blackburn Rovers after a replay.

Aware that victory would give them a cherished place in football folklore, the football careers of the would-be Invincibles were revealed in the newspapers of the day. The following entries were written about the players at the time:

Dr Robert Mills-Roberts (Goalkeeper)

A Welshman born in Penmachno in 1863, he first came under the public glare as captain of both rugby and soccer teams at Aberystwyth University. Moving on to London and the St Thomas's Hospital to complete his medical training, he became involved with a number of leading sides in the Metropolis. The Crusaders, Corinthians, Barnes and Casuals all had cause to thank him for some excellent goalkeeping in the various cup competitions. A regular in the Wales team, he first appeared for them in February 1885 at Blackburn against England. Recognising his outstanding goalkeeping skills, North End approached him in November to ask if he would sign up for their FA Cup campaign. He agreed, and all Preston rejoiced.

Robert H. Howarth (Right Fullback)

At twenty-two years of age, the popular defender had been in the North End team for over four years. He began his sporting days playing rugby for Preston Excelsior; whilst playing football in a medals competition he was spotted by Preston, who chose him for the second eleven. Soon after, the first eleven beckoned with a debut in October 1884. He never looked back, and a couple of England caps testified to his quality. His coolness in the tackle and his strong clearances make him a general favourite.

Robert Holmes (Left Fullback)

Born in Preston in 1867, he was educated at the Croft Street school. He joined North End for season 1882/3 and eventually progressed through the ranks to make his first team debut five years on; a capable defender and halfback on either side of the park.

George Drummond (Left Halfback)

Born in Edinburgh in January 1865, he began playing football when he was thirteen and was a gem of a player from the start, never having played in a second team in his life. A captain of Edinburgh St Bernard's, he joined North End for season 1883/4 playing on the right wing. He is a champion footballer, capable of filling any position if needed. His style of outwitting fullbacks is a delight for all to see.

David Russell (Centre Halfback)

One of the first natives of Scotland to be attracted to PNE, he arrived in season 1883/4 from a Scottish junior side and became a regular fixture in the side. After a season of indifferent form that saw him lose his place in the first team, he soon got back to his best. In the opinion of some, he is the finest centre half in the country. He often dons the Lancashire county colours, being a stalwart of the county team.

John Graham (Right Halfback)

Born in Ayrshire in 1857, halfback and the elder statesman of the North End team. He took up football at the age of eighteen and was soon in the ranks of the Third Lanark football team, and then the Annbank club where North End noticed him. Capped by his country while still north of the border, he soon became a prominent member of the Preston side. His burly figure and consistent form make him a crowd favourite.

John Gordon (Outside Right Wing)

He joined Preston in December 1883 from Port Glasgow, having been a member of the Athletic Club. It was a big step up for him but he soon adapted, gaining recognition for being remarkably fast, a good dribbler and dodger, and having one of the best screw shots in the business. Often pressed into service to play for the county side.

Jimmy Ross (Inside Right)

The brother of former team captain Nick Ross (who moved on to Everton), Jimmy was born in Edinburgh and arrived in Preston shortly after his brother. In Scotland, he was connected to the Hearts juniors and, on his arrival in Lancashire, he played for a couple of local sides before making the Preston second team. It was obvious that he was a promising player, and he soon progressed to the senior side. Although small in stature, he is regarded by many as one of the most lethal strikers in the kingdom.

John Goodall (Centre Forward)

Born in London in 1863, he was taken to Scotland as a child; on leaving school, he entered the local ironworks as an apprentice. A football player from his early teens, he became a prominent player with Kilmarnock. When he arrived back in England in 1883, he joined up with the Great Lever club. A couple of years on and Preston beat Bolton to his signature. An England international, described as second to none, his dribbling and shooting are close to perfection.

Fred Dewhurst (Inside Left)

Born in Fulwood in December 1863, Fred Dewhurst is one of the best-known players in the country. He made his Preston debut in January 1883, after coming through the Deepdale ranks. A regular choice in the England team, with caps and goals mounting up. A remarkably strong dribbler and often, at close quarters, a terror to the opposing goalkeeper.

Sam Thomson (Outside Left Wing)

He arrived from Scotland in season 1883/84 and was an instant success on his Deepdale debut, netting four goals. A wiry winger whose crosses often create chances for his team mates. Always having an eye for goal, he netted thirty in his first full season.

Missing through injury from the Kennington Oval line up
Alex S. Robertson (Right Halfback)

Born in December 1860 in Edinburgh, he began his career as a right-winger amongst the numerous clubs of his home city. Preston spotted him playing for St Bernard's and, once at Deepdale, he soon developed into a model halfback with good shooting ability, capable of robbing his opponents in the neatest manner and feeding his forwards with precision passes.

Kennington Oval Match Day.

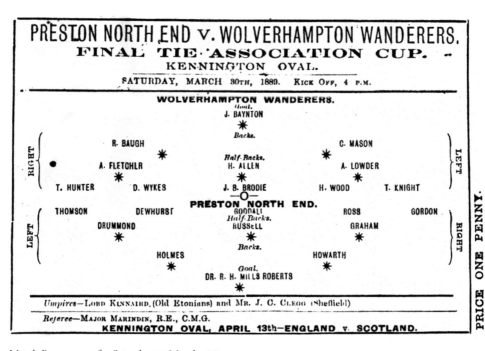

Match Programme for Saturday, 30 March 1889.

Also absent was regular goalkeeper Jimmy Trainer, who gave way to Mills-Roberts for the FA Cup campaign.

These were the players who generally had performed with great distinction throughout the Football League campaign, although John Edwards, Archie Goodall, William Graham, Jock Inglis and Richard Whittle had all put in odd appearances as required.

Similarly to twelve months earlier, crowds packed into Fishergate to hear news posted at the LEP as PNE took the field against Wolverhampton Wanderers in the FA Cup Final before a 29,000 Kennington Oval crowd. The first telegraph message had the crowd roaring their approval, as it was announced that Fred Dewhurst had put PNE a goal up on fifteen minutes. Ten minutes later, the wires were busy again and the notice in the LEP window read 'PNE 2 Wolverhampton Wanderers 0 – goalscorer Jimmy Ross'.

Several thousands stood and waited in Fishergate, and the whole town was at a standstill, eager for any snippet of information. It came midway through the second half, when it was announced that Sam Thomson had scored a poacher's goal after good work by Dewhurst. All that was needed now was final confirmation from the Oval that the task was complete, and it arrived just before six o'clock that night. The crowds gathered and delivered a rousing mighty cheer in response to the news that the historic double was complete. To win the league without losing a match and to win the FA Cup without conceding a goal was the stuff that legends are made of – Invincible, the North End had become.

25

THE GOLDEN DAYS OF DOCTOR SYNTAX

Every year since 1780, the Derby Stakes are contested at Epsom; it is a highlight of the racing calendar and is named after the 12th Earl of Derby, a familiar figure in these parts. Around that time there was horse racing upon the Preston Moor and, from 1786, it enjoyed the patronage of the Preston Corporation. The races were very competitive and the Preston Races attracted horses from far afield, with the Preston Gold Cup being a much sought after prize.

Until recent times, the Doctor Syntax public house stood on Fylde Road, in Preston, a survivor of the nineteenth century. This public house had, over the years, displayed numerous attractive signs, depicting on one side the eponymous fictional medical man, and on the other side the racehorse named in his honour.

The brown horse (foaled in 1811, and bred by Mr Knapton of Huntington) was to earn legendary status in its lifetime, with its outstanding feats on the racecourses of

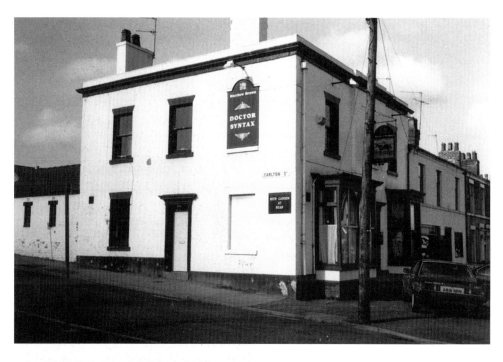

Above: The Doctor Syntax public house on Fylde Road.

Left: The fictional Dr Syntax.

The inn sign depicted the Gold-Cup winning horse.

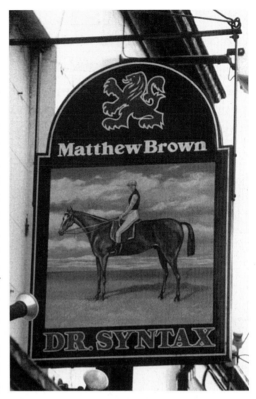

northern England, particularly the one on Preston Moor.

The years that would make Doctor Syntax a racing favourite began in July 1814. The horse's first outings had been in April, at Catterick, where it took a tumble, and four days later when it finished second at Middleton. In July, the horse (owned by Mr R. Riddell of Felton Park, Northumberland) was brought to Preston to take part in a 2-mile race on Preston Moor, and claimed the purse of £70. By October, when the season drew to a close, Doctor Syntax had claimed five victories from his eight outings.

As a four year old, the horse emerged as a top racer, with the Middleham Gold Cup being won in April, a Lancaster Gold Cup in late June, and a third 100 guineas prize being earned with a Preston Gold Cup victory in mid-July. In all, seven outings brought six victories and also great credit to the jockey, R. Johnson.

The subsequent years were equally successful as the horse took on the best that the aristocracy could muster, with the horses of Lord Derby, Lord Queensbury and the Duke of Leeds unable to stop the gathering of Gold Cups, with jockey Johnson usually in the saddle.

The annual visit to Preston Moor in 1818 was seen as a stern challenge, with twenty-one runners in the field. Once again, however, the 3-mile course seemed to Doctor Syntax's liking and, despite carrying almost nine stone, the horse saw off the challenge of Lord Grosvenor's fancied horse Tagus. More Gold Cup victories followed at Richmond, Pontefract and Lancaster, besides the annual visit to claim the Preston trophy and the 100 guineas that went with it. Not until 1821 did the remarkable record of Doctor Syntax look under threat. Early that year, Reveller beat it at Lancaster to claim the Gold Cup there, and consequently the crowds that gathered for the return encounter on Preston Moor was well above the norm, attracting country folk from far and near. Eighteen horses took to the field, but Doctor Syntax was in front from the start and never wavered, earning a three-length victory over Reveller at more attractive odds than usual of 7-4. Seven successive Preston Gold Cups had been won, a marvellous achievement considering the competitiveness of the annual event.

Sadly, in Guild Year 1822, the remarkable run came to an end, the Gold Cup being contested in September as part of the Guild celebrations. The great and the good all

put their thoroughbreds in the field, most of them four to six year olds, including the classy rival Reveller. Alas, the eleven-year-old Doctor Syntax could not hold back time and had to settle for second place behind Reveller. The seven-times winner was watched by Guild Mayor Nicholas Grimshaw and other local dignitaries in its brave, but failed, attempt to add an eighth Gold Cup.

It was the last that Preston would see of this amazing horse, which collected another couple of Gold Cups before retiring in 1823. The horse's record was indeed impressive – forty-nine races and thirty-six victories, including twenty Gold Cups. It had been a glittering career, and it should come as no surprise that when the horse retired it sired another winner in Beeswing, who had a liking for the Newcastle Gold Cup, winning that six times.

Racing continued on the Preston Moor until 1833, after which the Corporation enclosed the area, and eventually 100 acres of the land was used to create our present-day Moor Park, which was officially opened in 1867 at a cost of £10,826.

Many a regular at the old inn in Fylde Road would no doubt have been happy to raise a glass or two in honour of Preston's glorious Gold Cup-winning horse.

26

GOODBYE OLD STAND

In the summer of 2007 the bulldozers moved in at Deepdale to demolish the old pavilion stand, the last structure linked to the twentieth-century Preston North End. The brick-by-brick dismantling closed another chapter of the club's illustrious past, with a new structure set to emerge on the site to complete the redevelopment of the ground.

For older folk it brought back memories from 1935 when the club, having consolidated their place in the old First Division – the Premier League of the day – decided to invest in the future and build the pavilion stand and paddock. In January of that year they had revealed the ambitious project, and work was soon under way. It was an undertaking that would cost in the region of £9,000, and the main contractors for the scheme were local tradesmen. It was felt that the three-storey structure, with dressing rooms, baths, massage facilities, recreation rooms, gymnasium, offices and a boardroom with walnut panelling, would be regarded as among the finest in the land.

Amongst the local contractors for the new stand were John Dillon & Son, the builders from Heatley Street; the Preston Gas Co., entrusted with the hot water boilers; Blackburn & Sons, of Isherwood Street, responsible for the steelwork and railings; Brown & Bennett of North Road, responsible for the plastering and the flooring; and Messrs Seward & Co. of Ribbleton Lane, suppliers of the central heating system.

By the time pre-season training got underway in July 1935, the North End players were able to use the new gymnasium, and there was an air of excitement about the

place. Intent on improving their squad under trainer Will Scott, the club had invested in four new senior players, with the signing of the talented brothers Frank and Hugh O'Donnell from Celtic, Thomas Crawley from Motherwell, and Walton, an understudy for goalkeeper Harry Holdcroft.

The club were pleased to announce that 350 reserved seats would be available in the new stand, at a cost of just over £6 for the season. The price included a luxury tip-up seat, afternoon tea, free parking and a match programme. It was stated that the price for the new paddock in front of the stand would remain the same as for the old standing area, and that – for the first time – the club had installed toilet facilities for both men and women.

Those eager for a glimpse of the new stand had an opportunity on the fourth Saturday of August, when the traditional public practice match took place between the first team and the reserves. In the event, the probable eleven (which included the new outfield signings) romped to a 6-1 victory over their understudies. The O'Donnell brothers both made a good impression in front of a 10,000-strong crowd. The pitch looked a picture of verdant green, set off by the freshly painted stands and terraces, and the club were pleased that they had declined to allow advertising hoardings within the ground. The players, after a fortnight's intensive training, looked fit and bronzed.

The Preston North End fixtures began on the last Saturday of August with a visit to Huddersfield Town. Despite holding firm for over an hour against a livewire Huddersfield attack, the North End fell to defeat when Richardson volleyed home from 30 yards. Although they had lost, the visitors were heartened by the form of the O'Donnell brothers against a team that looked likely to be battling near the top of the league.

On the following Monday night there was great excitement around Deepdale, as Preston North End welcomed Derby County for the first home match of the season in front of the new pavilion stand and paddock. Following a late rush for season tickets, the sides ran out in front of a Deepdale crowd of 29,333 spectators.

The North End's line-up for the historic match was: Holdcroft, Gallimore, Lowe, Shankly, Tremelling, Batey, Friar, Hetherington, Maxwell, Frank O'Donnell, Hugh O'Donnell.

Derby County proved to be formidable opponents and, for long spells, played attractive attacking football, with North End having goalkeeper Harry Holdcroft to thank for a couple of spectacular saves. In the event it was the PNE side that triumphed, thanks to a goal from Jack Hetherington, who tapped the ball home after a spell of Preston pressure. It was not the most inspiring of Preston performances, although their tenacity earned them the two points, to the delight of a crowd happy in their new surroundings.

It was reckoned that Preston North End now had a ground worthy of the top flight of the Football League, and their home record that season was one of the best in the division, with fifteen victories and a run of eight fixtures unbeaten. Indeed, it was only a poor 'away' record that prevented them from finishing higher than their seventh place finish, as skipper Bill Tremelling led from the front, playing in every league fixture.

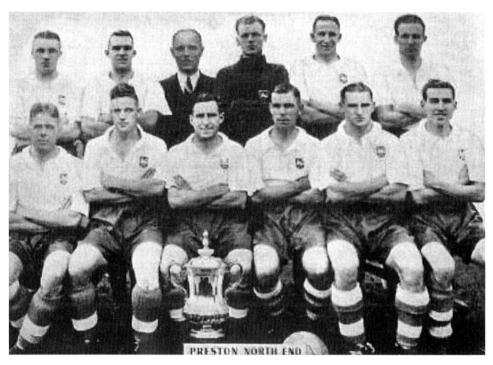

The Cup Holders with the coveted trophy.

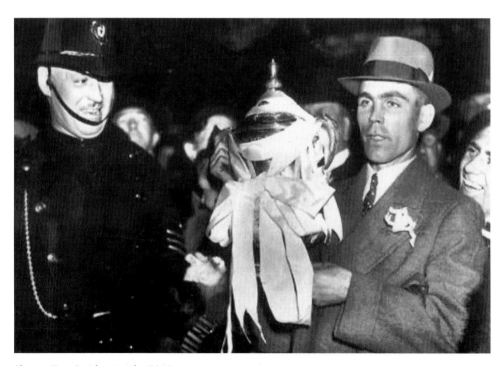

Skipper Tom Smith raises the FA Cup.

The new-found confidence of a side that, in true tradition, included a number of players from Scotland in their ranks, proved over the forthcoming seasons that the club's investment in ground improvements and new players had been well worthwhile. Whilst unable to match the feats of those Invincibles of half a century earlier, the team – strengthened by recruiting quality players such as Tom Smith, Bobbie Beattie and George Mutch – did nonetheless manage to reach two FA Cup Finals and a third-place finish in the Football League before the Second World War intervened.

A glorious FA Cup run in 1937 ended in a heartbreaking Wembley defeat, 3-1 against Sunderland, despite leading at the interval. Overwhelmed by the reception they received as they came home without the FA Cup, skipper Tremelling informed the gathered thousands that they would do all they could to return with the trophy twelve months later.

In fact, Tremelling had played his last game for his beloved PNE, but new skipper Tom Smith vowed to carry out the mission and, in early May 1938, the team were back on the Town Hall steps with the trophy held aloft. It had been a nail-biting occasion at Wembley, with the North End triumphant after George Mutch had converted a penalty, in the dying seconds of extra time, against a gallant Huddersfield Town.

It is hoped that the new structure that emerged on Lowthorpe Road will inspire the players of Preston North End, as the pavilion stand did all those years ago. If it does then we are in for a treat, without a doubt.

27

IMAGINE AN EASTER WHEN …

Imagine an Easter when PNE defeat Chelsea and Tottenham away from home – when 50,000 go egg-rolling on Avenham Park – the cinemas and churches are packed – and there is glorious sunshine.

Well, such an Easter occurred in 1956, when the feast came at the beginning of April. On Good Friday, all roads seemed to lead to the coast, as glorious sunshine greeted those heading off early. By mid-morning, over 1,500 vehicles an hour were reported on the Blackpool Road, and over 1,000 vehicles were making their way to Southport. Numerous excursion trains also headed for the seaside and it was no surprise that they were busy; temperatures were pleasant and ten hours of sunshine helped maintain the holiday spirit. Morecambe measured the crowd by the number of deckchairs hired out – it was three times more than normal – whilst in Southport the coffers were bulging, with 3,200 vehicles parked in the Corporation car parks.

Of course, many were content to stay at home, with scores of hot cross buns consumed while the traditional Good Friday church services had a healthy following. Many also had an ear close to the wireless, with the Preston North End team visiting

London to tackle Tottenham Hotspur and Chelsea in crucial relegation battles on consecutive days. On Good Friday, the fixture at White Hart Lane turned into a notable victory for North End after a goal-less first half. The Tottenham team was blitzed in the second half, with Tom Finney and Tommy Thompson both scoring twice in a 4-0 win that left the majority of the 40,000 home crowd far from happy. Stout defending was the order of the day on the Saturday, with a penalty converted by Tom Finney good enough to give North End victory at Stamford Bridge.

Local entertainment was plentiful, with fifteen cinemas to choose from. The Empire in Church Street showed *Daddy Long Legs*, the lavish musical starring Fred Astaire and, across the road at the Ritz, they were screening *Cattle Queen of Montana* in glorious Technicolor, starring Barbara Stanwyck and the future President of America, Ronald Reagan. The Carlton on Blackpool Road had the ever-popular Norman Wisdom in *Trouble in Store* and, at the Empress on Eldon Street, *Son of Sinbad* was on offer twice nightly. For those who preferred the theatre, there were a few seats still available at the Royal Hippodrome on Friargate to catch *A Girl Called Sadie*, described as a sensational sex play.

In 1956 the crowds flocked to Avenham Park, just as they did in early Edwardian days.

Preston Greyhound Stadium in Acregate Lane hosted a Saturday night of racing, and on Easter Sunday you could go cruising on the Lancaster Canal for a couple of shillings, setting off from the Kendal Street wharf. For those who liked to be strictly ballroom, Saturday was the night for a dance date at the Public Hall, or the Regent Ballroom where Eddie Regan and His Orchestra performed.

As ever, Easter Saturday was a popular day for brides, with church bells ringing out all over town as local couples tied the knot. The busiest church on this occasion was St Andrew's in Ashton, where eight weddings took place within a matter of hours. The last wedding of the day took place between Kathleen Bull, a nurse at Preston Royal Infirmary, and salesman Frank Lodge, with her nursing sisters as bridesmaids. A packed programme of Easter services followed on the Sunday; the vicars, priests and preachers looked forward to their Bank Holiday on Easter Monday.

On Easter Monday morning, a crowd of 27,000 flocked to Deepdale to welcome back North End after their exploits in London. There were no complaints about a packed fixture list from these lads, who would have been glad of £20 per week, never mind £20,000. In the morning sunshine, they raced into a 2-0 lead inside ten minutes against Tottenham Hotspurs, thanks to goals from Tommy Thompson and Willie Forbes. Unfortunately, North End seemed to be feeling the effects of their exertions, and a ragged performance followed as the visitors rattled in three goals to take the lead. Only a late goal by Hatsell spared North End a defeat, his shot finding the net after deflecting off the post. Nonetheless, it had been a profitable Easter for North End, with the points going some way to ensuring their safety from relegation.

Once the football was over, the thoughts of many turned to egg rolling at Avenham Park. In fact, over 50,000 turned up at the park – the biggest turnout for years – all happy to enjoy the glorious sunshine of a spring-like day. Scores of children rolled their hardboiled eggs down the slopes, and the eggs were dyed all colours of the rainbow. It was reckoned that the eggshells were thicker than in previous years, and could take quite a battering before they cracked. Many an Easter bonnet was on parade, gaily decorated with ribbons, and the local lassies were a sight to behold in their summer frocks. As usual, a number of children were parted from their parents in the excitement of the occasion, although all were reunited thanks to the park attendants. One two-year-old boy, who had a habit of getting lost, produced a card from his pocket, with his name and address neatly written on it by his parents.

Of course, the motorways were still a distant dream and the roads of the North West were jammed as the holidaymakers headed home that Easter Monday evening. It was nose to tail from Blackpool, and an 8-mile queue tested the patience of the motorists. There were traffic jams on the roads from the Lake District too; many had journeyed there for picnics in the glorious sunshine, or to climb the hills and fells and, returning by car or coach, the journey home was slow.

Resuming work on the Tuesday, many were a little tired after their action-packed Easter, but generally the feeling was that it had been an Easter to remember.

ALL THE FUN OF THE WHITSUNTIDE FAIR

Every year, crowds flock to the annual fair held in Preston city centre over the Spring Bank Holiday weekend. The former Whitsuntide Fair dates back to the early years of the nineteenth century, when it was held on the land known as the Orchard before the Covered Market was erected. The fair is still a local attraction, although the other great event of the Whitsuntide break – the Whit Monday church processions – are no longer held.

Amongst the early local pioneers of the fair was George Green, who lived in Back Lane and was a cabinet maker. Back in 1860, he went into the fairground business when a customer failed to pay for a stud of carved hobby horses due to be exported to America. Enterprising as he was, he built a merry-go-round of his own to utilise the wooden figures. It was the start of a link with the world of the showman that would span the centuries, and lead to five generations of the Green family providing funfair fun for Preston folk. John Green followed his father in the fairground business, and for a time combined his fairground work with running the Farmer's Arms public house in the town.

The business was certainly expanding, and by the 1920s they had a miniature railway and an American Caterpillar ride to boost the business. For the next generation of fairground folk, romance brought the Greens and Mitchells together, when Robert Green wed Eleanor. A roving caravan life followed and the Whitsuntide Fair in Preston remained the most popular on their calendar.

Up to a dozen people were regularly employed by them, erecting and maintaining the rides throughout the season, and Robert took great pride in the elaborate murals and scroll work that he himself painstakingly decorated his merry-go-rounds with.

The Greens with their Caterpillar ride, Shaw with his Monorail, and the Mitchells' Speedway, along with numerous other roundabout owners, were joined by many a sideshow, with the likes of the sword swallower, fire eaters, lion tamers, riders on the wall of death, and performing fleas bringing in the crowds. No Whitsuntide Fair would have seemed complete without Hughes' Boxing Booth, Sedgwick's Zoo, Professor Anderton's Magic Show or even Harrison's Parched Pea Saloon.

Prior to the Second World War, the fairground peepshows were as popular as the roundabouts, with crowds flocking to see the fat lady, the thin man, the tattooed woman, the pig-faced lady – and not forgetting Frederick the Giant and the ever-popular India Rubber Man, who was able to lift the skin from his chest until it partially covered his face. If you lasted three rounds with one of Bert Hughes' fighters then you got 10s – an irresistible challenge for any young tough. The challenge of the hoopla stall, the bid to get the ping pong ball into a goldfish ball, or three darts into different playing cards, all added to the fascination of the fairground – and all for a coconut or a goldfish.

The Whitsuntide Fair arrives in Preston.

Another family that became forever linked to the Preston Annual Fair was that of Richard Dewhurst who, in 1870, started to travel around the county's villages with a small roundabout turned by a mule. As his sons grew up, their fairground contribution increased and, besides providing coconut shies and shooting galleries, the family also invested in a magnificent steam-powered roundabout that had a multitude of leaping, fiery-eyed horses, with a impressive steam organ in the centre that played an endless melody of marching and waltzing music.

Once James Dewhurst had control of the travelling show, it became one that all Lancashire flocked to see and enjoy. Every spring, the Dewhurst cavalcade of caravans and wagons set off on its seasonal tour around the Lancashire countryside. There were swing boats, hobbyhorses, and a multitude of sideshows to catch the eye of the country dwellers in the villages that it visited.

The annual visit to the Preston Whitsuntide Fair was a highlight of the Dewhursts' year; the town remained their base when winter came, their encampment being originally where the Preston Market Hall now stands, before a move to Ripon Street. After service in the Second World War, Harold Dewhurst took over the running of the

A traditional Whit Walks scene.

family business and began transforming the fairground power supply from steam to electricity. It led to a spell of post-war prosperity and pleasure for another generation of fairground visitors. Alas, by 1960 escalating costs forced the Dewhursts to call time on their fairground life and they retired to their caravan home behind the high-fenced wooden stockade that was their Ripon Street base.

The fairground has continued despite criticism from some quarters. Surely it's not a nuisance, a menace to health, an eyesore – all remarks hurled in its direction down the years. After all, it brings a spirit of light-hearted nonsense and frivolity, a whirl of surprise and thrills, and a riot of noise and humanity – according to the showman Alfred Testo, some seventy years ago. This was the man who brought the headless woman illusion to Preston, along with a troupe of women wrestlers. The most difficult task, in his opinion, was flea training – only one person in a million being capable of performing that task. Fortunately, his daughter was a marvel at it – with good eyesight, a steady hand and unending patience.

No doubt the travellers of old would look with amazement on the high-tech advancements of the present-day pleasure rides, as they arrive in the city on their low loaders and trailers to provide another holiday of thrills.

WAKING UP TO WAKES WEEKS

Since the growth of industrial Lancashire in the nineteenth century, the towns and cities of the county have observed an annual shutdown during the summer months.

In the nineteenth century, the closure was seen by many of the employers in the cotton industry as an opportunity to service the machinery, and certainly not as a chance to give the workers a well-earned break. In fact, it was often only a couple of days – which was perhaps just as well, for it generally meant no work, therefore no pay, and only those who had put some cash in savings schemes were able to spend the time away.

Just over 100 years ago, a significant change took place in the life of the Preston folk when the traditional Wakes Week was formally established. Throughout the local industry it was agreed that an operatives' holiday should be observed, lasting the entire second week of August. For a number of years the weather in August had not been particularly good, but the sun certainly shone on the holidaymakers of 1905.

From the Friday evening, and on through Saturday, Preston railway station reported its busiest ever period; crowded platforms and passengers jostling for a place in a carriage on an excursion train. Would-be travellers, with suitcases and half a dozen eager children in tow (the eldest trusted with carrying some vital piece of luggage) hoped to find a seat for their journey to the seaside.

The booking office had never known anything quite like it; Blackpool was the main destination, followed by Morecambe, Fleetwood and Southport, whilst those with more money headed for the Isle of Man or the Lake District.

The initial rush was followed by a record number of day-trippers on each subsequent morning. Indeed, on the Saturday, many who had not had the foresight to book their accommodation in advance found that Blackpool was fully booked, and after tramping from one lodging house to another ended up on the late train back to Preston.

During the week some 5,000 daily tickets were bought for Southport, and Blackpool had 3,000 visitors each day from Preston alone, many eager to meet up with family and friends who had booked a seven-day break, and walk along the newly opened Promenade. Frame's Excursion – the leading Preston tour operator – reported a record number of bookings to destinations such as London, Dublin and Llandudno.

Judging by church attendance on the Sunday morning, it was apparent that many of the flock had embarked on their cherished holiday and their prayers for sunshine had been answered. Apart from the early morning rush to the railway station, the town was somewhat deserted throughout the week. With the factory chimneys not smoking, and the wheels of industry at a halt, the place took on a more serene look. The leading department stores also allowed their staff three or four days off, so the usual hustle and bustle of shoppers was absent from the scene.

Of course, many poorer families could only afford the odd outing, and on the other days there was a marked increase in visitors to the public parks, with many a father

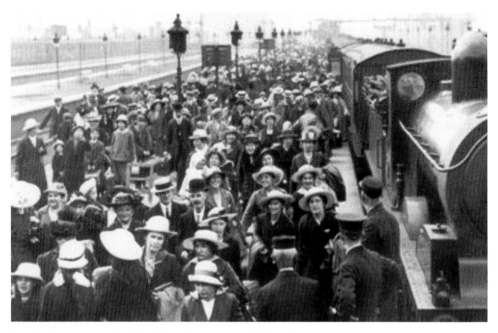

A typical scene as crowds of holidaymakers arrive at Blackpool.

glad to have some time at play with his youngsters. In Avenham Park, a band concert was held; at Farringdon Park, a race meeting took place with the finest trotting horses on show, and quite a number ventured down to the River Ribble for a family trip on a rowing boat.

Up until the Second World War, Wakes Week became a tradition throughout the Lancashire towns; it was only in the post-war years that one week became two, at which point the break was switched in Preston to the last fortnight in July. By this time, the workers had won the right to paid holidays and so the break was more enjoyable.

Blackpool was a popular holiday choice because even if it rained you could dance on the Central Pier in the morning and at the Winter Gardens at night, and in between stroll along the Promenade. The Lancashire seaside resorts remained the most popular destinations and the youngsters of the 1950s and '60s enjoyed what seemed an endless fortnight of daily trips to the seaside with bucket and spade, and eating sardine sandwiches on the sands after bringing the jug of tea from the nearby kiosk. The steam-hauled train from Southport seemed to take an eternity to get back home, and tired legs would trudge back from the railway station. Then, after a peaceful sleep, it was time to set off again – shoes cleaned, socks pulled up, sandwiches packed by mum and this time Morecambe maybe, or even Heysham Head.

These days the school holidays usually start at the traditional time of Preston holidays, and most industries carry on business as usual. Seaside holidays have been replaced by flights abroad, and a trip to the seaside is a common occurrence not reserved for the holiday fortnight. Mind you, nothing could taste quite like those sardine sandwiches with a sprinkling of sand in them.

THOSE TWENTIETH-CENTURY CHRISTMAS TIMES

The twentieth century, without doubt, helped to shape the Christmases that we now enjoy. This look back at past Preston Christmases shows how the way we celebrate the great occasion has changed.

Deck the Halls with Boughs of Holly

In the days leading up to Christmas 1903, the main streets of Fishergate and Friargate had an endless stream of shoppers, with many of the familiar Preston stores reporting hectic trading. Messrs E.H. Booth & Co. were offering Christmas hampers from 5s to £5, packed with choice goods and fine wines. Even Christmas crackers containing jewellery were on offer. Also in the jewellery business was H. Samuel, who was selling men's solid silver watches for 7s and ladies' gold watches in engraved cases for 25s.

The popular ironmongers Slingers & Son were offering the very latest in mincing and chopping machines – a necessity for the housewife of the time, it seems.

At the Royal Infirmary and the Fulwood Workhouse, staff went to great trouble to make the season a happy one, with the halls bedecked with garlands, holly, ivy and mistletoe, and large Christmas trees added to the enchanting scene.

Christmas Day mail delivery was still a requirement for the poor postman, with over 90,000 Christmas greetings delivered that morning.

God Rest You Merry Gentlemen

A hoar frost arrived on Christmas Eve 1908, whitening the leafless trees, the roofs and the roads; the town's Catholics had to wrap up warm for their trek to Midnight Mass. By morning the air was dry and brisk, and many more ventured to the town's churches and chapels. The great religious festival was suitably celebrated with services of praise and an uplifting feeling as the choirs of the town sang Christmas carols. The choir of St Paul's earned particular praise as they toured the hospitals and institutions, spreading tidings of comfort and joy wherever they went.

The weather was chilly in 1908, as this Moor Park scene in the grip of a Hoar frost shows.

That's Entertainment

The run-up to Christmas 1913 was a bright and cheerful one in Preston, and, on Christmas Eve, the streets were filled with shoppers. Many a child woke to find either a tricycle or a wooden rocking horse awaiting them on Christmas morn. The day itself dawned, blustery and dark, and gusting winds and heavy showers greeted the early callers – but nothing could dampen the Christmas spirit.

There was plenty of entertainment for those who braved the showers, with a programme of entertainers, comedians and farce on at the newly opened Empire Theatre, the Palace Theatre and the Theatre Royal. Those who enjoyed a pantomime could choose from 'Little Red Riding Hood' at the Hippodrome and 'Aladdin and His Wonderful Lamp' at the Princes Theatre.

Let There be Peace on Earth

Christmas 1914 saw the country at war, and the local folk attempting to shield the youngsters from the reality of a war-torn country. Just days before Christmas, a German

bombardment of the north-east coastal towns of Scarborough, Hartlepool and Whitby, which claimed over 100 lives, left the nation shocked. This, in addition to the stream of news from abroad listing soldiers dead or wounded, made thoughts stray far from the festive season. A letter from local soldier Private Kelsall, who had been wounded at the front, told of life in the trenches under constant fire.

Good Christian Men Rejoice

After four years of Christmas under the shadow of war, 1918 heralded a happy change as a Victory Christmas was celebrated. For many families the traditional Christmas reunion was to be incomplete, with the tragic losses on the battlefield leaving many a fireside chair empty forever.

As things transpired, many sailors and soldiers got special Christmas leave and there was much rejoicing at their homecoming. Many wounded soldiers were looked after at the local hospitals, and there was ample turkey and goose reared on the local farms to ensure the Christmas dinner was suitable for returning heroes.

We Need A Little Christmas Cheer

The Christmas of 1924 was looked forward to with great anticipation by the children at the Harris Orphanage. A large Christmas tree was laden with gifts for the children and this year its appearance was enhanced by coloured electric lights. It was not, however, a very healthy Christmas for the youngsters, with a number of them suffering from the epidemic of measles that had hit the town.

I Saw Three Ships Come Sailing in

Preston enjoyed one of the best Christmases for years in 1935, with the town in a period of prosperity. The cotton trade had been steady and the unemployment figures were the lowest they had been for six years, with 9,000 signing on. Turkeys were carved and plum puddings were steaming in homes and institutions.

The hoped-for snow did not materialise, with the frost that had lingered for a week before Christmas being replaced by squally showers, thwarting those intent on winter sports.

In keeping with the times, many a fortunate received an electrical gift such as a kettle, toaster, coffee maker or electric iron and, for comfort on a chilly morning, there was a two-bar electric fire. The only problem would be the electric bill in January.

Down on the Preston Docks, a large number of ships were berthed for Christmas, including the Finnish vessel *Vivcia* and the Norwegian steamer *Vestfos*; the sailors on board were treated to their traditional national Christmas dinner. In the evening, many of them gathered at the Sailor's Rest, where they were freely entertained.

Let it Snow! Let it Snow! Let it Snow!

Imagine snow whirling past the windows, the Yule log burning brightly on the hearth, and the fellowship of the fireside, and you have an idea of Christmas 1938. Bare trees glistened with hoar frost, the ground was covered with a carpet of white, and ponds were frozen over, making Preston look like a picture on a Christmas card.

Last-minute shoppers had to cope with pavements like a sheet of ice, but nothing could deter that festive feel in the air, not even the odd frozen water cistern or burst water pipe.

I'll be Home for Christmas

By Christmas 1941, Preston had got used to wartime living and the festive season was no exception. Inside the shops there were patient queues of people fingering coupon books, knowing exactly what they required after weeks of self economy on such items as sugar, dried fruit and eggs, in order that the plum pudding and mincemeat would be up to standard.

A sense of duty meant a shorter break, with the men out on their posts as special constables, air-raid wardens, part-time firemen, and first-aid workers, or working with the Home Guard. When Christmas dinner was served, many a table had cherished loved ones missing. Traditional Christmas presents were in short supply – lucky was the lady who received a pair of silk stockings.

Peace on Earth, Goodwill to All Men

Christmas 1945 arrived with pouring rain, but this couldn't dampen spirits as Preston at last had a peaceful Yuletide. The war was over after six years of grim conflict. Just twelve months earlier, Hitler had bestirred the folk of the North West with a few flying bombs for Christmas.

The peaceful occasion inspired local poet Miss Dowse to pen the following verse:

Christmas is here again,
How different now
From the last, when men
Were fighting, hand and brow
To bring us peace on earth,
Peace on Earth. The Saviour's Birth,
Come rejoice again!

The men were not all back yet, but they were expected in the New Year and many Christmas messages were transmitted on the wireless sets, including the King's Christmas Day Message to a nation at peace.

I'm Dreaming of a White Christmas

Christmas 1956 was very much a stay-at-home Christmas, with howling south-easterly winds on Christmas morning which were a prelude to the coming snow. On Christmas night the snow arrived and, driven by the gales, it was soon a blizzard, its depth ranging from a light covering to drifts several feet deep.

On Christmas Day, Preston North End had visited Burnley, where over 23,000 spectators had braved the chilly weather to see the North End earn a 2-2 draw with two goals from Tommy Thompson. The return clash on Boxing Day was played on a Deepdale pitch covered with a layer of crisp, powdery snow that made playing conditions very tricky. It looked like a scoreless draw would be played out, until a Les Dagger shot was deflected past the Burnley goalkeeper by one of his defenders – to the delight of most of the 19,265-strong crowd.

When a Child is Born

Christmas 1969 came along with the town in the grip of an icy and foggy spell, which caused havoc on the roads. And, with over fifty staff absent due to an influenza epidemic, Preston Corporation were struggling to keep the bus service going. It all added up to a stay-at-home Christmas for most, with a number being confined to bed after catching the flu bug.

The local hospitals had a higher than usual number of patients on Christmas Day, with three births at the Preston Royal Infirmary and a couple more at Sharoe Green Hospital – four girls and a boy and all doing fine was the bulletin. Top of the Christmas hit parade was Rolf Harris with 'Two Little Boys'.

Ding! Dong! Merrily on High

Christmas 1977 was a wet one, with showers following a Christmas shopping bonanza, the tills having rung merrily for weeks. Those who stayed at home had their share of turkey, Christmas pudding and mince pies, and for those who liked their television there were plenty of films, from the *Wizard of Oz* to *Funny Girl* to keep them entertained. Not everyone stayed at home; the travel agents reported that foreign holidays at Christmas were on the increase. Another sign of the times was the start of the January sales on Boxing Day.

Do They Know It's Christmas?

The Christmas of 1984 saw the introduction of late-night shopping in Preston. Thousands thronged to the night-lights and the new venture was hailed a roaring success. Inspired by Bob Geldof and a host of musical entertainers, the Band Aid single

'Do They Know It's Christmas?' made the top of the hit parade, with many Preston folk helping to swell the charity coffers.

Snowflakes Fall, Are You Listening?

In the build-up to Christmas 1993 there was heavy rainfall and the inevitable flooded roads to follow. Christmas Day itself saw a little snow falling in Preston, earning it a place on the White Christmas list. Preston Council was in a generous mood, giving away some 10 tons of canned stewing steak to the poor and homeless – it was part of the European Community surplus. Teenage heart-throbs Take That made it to the top of the charts for Christmas with 'Babe', edging out Mr Blobby.

We Wish You a Merry Christmas

It all seems a far cry from the nineteenth century, when the editor of the *Preston Chronicle* had the following choice words for his readers:

> Some folks' ordinary days are as good and better than other people's Christmas; they have their music and enjoyments as usual, but are not a fiftieth part as merry as they might be.
>
> Others who are in the habit of paying their religion extraordinary compliment think it profane to be merry at all. And others hardly think about the matter, except just enough perhaps to keep up the beef and mince pies.

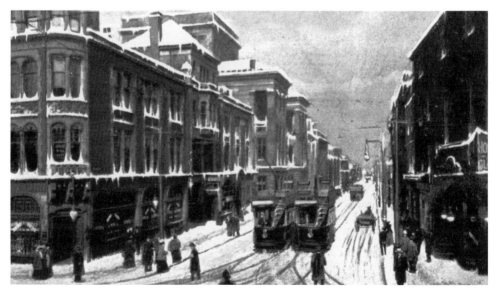

Looking down a snowy Lancaster Road in Edwardian Days.

Other titles published by The History Press

Lancashire's Sacred Landscape
LINDA SEVER

Lancashire, situated in the north-west of England, does not, at first, tend to conjure up images of a 'sacred' landscape, but look at bit deeper and one will discover a vast array of sites of ritual and early worship. Within this book the reader will find a comprehensive gazetteer of prehistoric sites, listings of place names, locations of stone sculpture and detailed analyses of carvings and the inscriptions upon them. Extensive photographs illustrate the sites described within the chapters.

978 0 7524 5587 7

Prehistoric Lancashire
DAVID BARROWCLOUGH

What was life like for the prehistoric inhabitants of Lancashire? This is the first book to look at the history of the county from the Mesolithic to the Iron Age period. Out of this study emerges elements of a uniquely Lancastrian prehistoric culture which at the same time shared the core values of the wider British prehistoric period. With new data from unpublished sites and exceptional illustrations, this book is of interest to both scholars and the general public.

978 0 7524 4708 7

A Grim Almanac of Lancashire
JACK NADIN

A Grim Almanac of Lancashire is a day-by-day catalogue of 365 ghastly tales from around the county dating from the twelfth to the twentieth centuries. Full of dreadful deeds, macabre deaths, strange occurrences and heinous homicides, this almanac explores the darker side of the county's past. This compilation contains diverse tales of highwaymen, murderers, bodysnatchers, poachers, witches, rioters and rebels, as well as accounts of old lock-ups, prisons, bridewells and punishments.

978 0 7524 5684 3

More Lancashire Murders
ALAN HAYHURST

In this follow-up to *Lancashire Murders*, Alan Hayhurst brings together more murderous tales that shocked not only the county but made headline news throughout the nation. They include the case of Oldham nurse Elizabeth Berry, who poisoned her own daughter for the insurance money in 1887 and Norman Green, who was hanged for the murder of two young boys in Wigan in the 1950s. Alan Hayhurst's well-illustrated and enthralling text will appeal to everyone interested in the shady side of Lancashire's history.

978 0 7524 5645 4

Visit our website and discover thousands of other History Press books.
www.thehistorypress.co.uk